collage discovery workshop

CLAUDINE HELLMUTH

NORTH LIGHT BOOKS
CINCINNATI, OHIO
www.artistsnetwork.com

{About the Author}

Claudine Hellmuth is a nationally known collage artist whose work has been chosen as fine art poster designs, featured in numerous magazines, used as book cover artwork and published as rubber stamps, journals, magnets, greeting cards, drink coasters and more.

With an education background in fine art from the Corcoran College of Art, Claudine approaches collage the old-fashioned way. She enjoys the challenge of working with a variety of materials and cutting, pasting and painting her artwork by hand. In addition to working on her art full-time, Claudine teaches mixed-media collage workshops in the United States and Canada.

Claudine's studio and home is in Orlando, Florida, where she lives with her husband, Paul, and their very spoiled four-legged children—the cats Melvis and Maggie and Toby the wonder dog. To learn more about Claudine, visit her Web site at: www.collageartist.com.

ABOVE RIGHT: **Count the Boundaries** 6" × 4" × 2" (15cm × 10cm × 5cm)

Collage Discovery Workshop © 2003 by Claudine Hellmuth. Manufactured in China. All rights reserved. No part of this book may be reproduced in any form or by any electronic or mechanical means including information storage and retrieval systems without permission in writing from the publisher, except by a reviewer, who may quote a brief passage in review. Published by North Light Books, an imprint of F&W Publications, Inc., 4700 East Galbraith Road, Cincinnati, Ohio 45236. (800) 289-0963. First edition.

07 06 05 04 5 4 3 2

Library of Congress Cataloging-in-Publication Data

Hellmuth, Claudine
 Collage discovery workshop / by Claudine Hellmuth.
 p. cm.
 ISBN 1-58180-343-5 (alk. paper)
 1. Collage. I. Title.

TT910.H45 2003
702'.81'2—dc21
 2003051285

Editor: Liz Schneiders
Designer: Stephanie Strang
Cover Art: Claudine Hellmuth
Layout Artist: Kathy Gardner
Production Coordinator: Sara Dumford
Photographer: Tim Grondin and Christine Polomsky
Photo Stylist: Jan Nickum

metric conversion chart

TO CONVERT	TO	MULTIPLY BY
Inches	Centimeters	2.54
Centimeters	Inches	0.4
Feet	Centimeters	30.5
Centimeters	Feet	0.03
Yards	Meters	0.9
Meters	Yards	1.1
Sq. Inches	Sq. Centimeters	6.45
Sq. Centimeters	Sq. Inches	0.16
Sq. Feet	Sq. Meters	0.09
Sq. Meters	Sq. Feet	10.8
Sq. Yards	Sq. Meters	0.8
Sq. Meters	Sq. Yards	1.2
Pounds	Kilograms	0.45
Kilograms	Pounds	2.2
Ounces	Grams	28.4
Grams	Ounces	0.04

dedication

⭐ TO MY HUSBAND, PAUL, without your constant cheerleading and support,

I could never have the freedom to do what I love.

⭐ AND TO MY PARENTS, thank you for always believing in me and encourag-

ing me to follow my dreams.

acknowledgments

I would like to thank North Light Books for believing in me as a first-time author.
I would also like to thank my editor Liz Schneiders for all her hard work and ingenious
ideas. Also, I want to say thank you to designer Stephanie Strang, photographer Tim
Grondin and the many other people along the way who have made this book something
that I am truly proud of. To all of you, thank you.

18 *creative collage techniques* ## 60 *piecing it all together*

the magic *of* Collage

What Is Collage? Collage is defined by *Merriam-Webster's Collegiate Dictionary* as "AN ARTISTIC COMPOSITION MADE OF VARIOUS MATERIALS (AS PAPER, CLOTH, OR WOOD) GLUED ON A SURFACE." That's exactly what it is! You can use any materials in any way and glue them down to create a piece of artwork. What could be more exciting or full of creative possibility than that?

You Don't Need to Be an Artist

Collage is unlike any other artistic medium because you don't have to start from scratch. You can "borrow" already existing materials to make your art piece and to tell your story. Therefore, you do not have to be a great artist to create a collage or enjoy doing it. You do not even need to know how to draw! You simply need to open your imagination and let yourself be free to try new things, and soon you'll be having a lot of fun.

It's All About Play

I think as you start to try collage you'll begin to see that collage is all about play and pasting materials down and seeing what happens next. There is no way to make a mistake! If you don't like something, you can paste over it, paint over and add something else. There is no way to fail.

Find Your Creative Voice

Did you know that simply experimenting with collage can help you find and improve your creative voice? As I work on my collage pieces I like to ask myself questions. Why do I like a certain color, pattern or arrangement? Why do I choose this piece and not that one?

Ask yourself these questions often enough and you will learn to trust your own creative talents. And your artwork will get better because of it. I have added journaling prompts on page 105 to help you on your creative journey.

The World Is Your Resource

After you have been working in collage for a little while, you will start to see that everything in your life could be possible source material for your artwork. That candy wrapper that you just threw away, the postmark from the letter that you got in the mail yesterday, the pages from your vacation journal. All of these can become source material for collage artwork. You do not need to spend a lot of money on expensive antiques or materials. In fact, the more creative you are in finding materials, the more fun it can be!

My Wish for You

I want to reassure you that making art isn't something that should be intimidating or scary! It's about trying new things and seeing what might happen. It's asking "What if?" that is so important to the creation of art!

I hope that by reading this book and using some of my tricks of the trade, you will fall in love with working in collage as I have. It's an unpredictable and exciting road. You never know what's going to happen. That's what makes it so fun! Let's get started!

{How To Use} THIS BOOK

This book is not only about pasting papers to a surface; it is a medley of ideas, techniques and lessons about being an artist that I would like to share with you.

>>Learn the Basic Techniques

To get started, I will introduce you to the basic tools and supplies needed to make collage art, followed by some basic techniques. The first half of this book, "Creative Collage Techniques," focuses on all my favorite techniques. I will begin by teaching you how to create a variety of luscious backgrounds by glazing and layering paint, aging materials, peeling paper and peeling paint. Use these background techniques to tackle the "blank canvas" syndrome. I find they help me jump in and get moving on my collages, and I think you will find that they will help you, as well.

Next, I will show you several different techniques for transferring images to your collage surface. These techniques can enhance your collages with wonderful depth and transparency. You will also find demonstrations on how to rust metals, create collages with beeswax and use other texture-building methods.

>>Put It All Together

The second half of the book, "Piecing It All Together," introduces a series of creative collage exercises that will help you put basic collage techniques into practice. These exercises are meant to open your eyes to the different ways you can create a collage. As you go through each exercise, you will hear me share my thoughts about each piece as it evolves. As you listen to what I am thinking about as I work on a collage, I hope you will learn to ask yourself the same questions. I have even included some helpful journaling prompts that will aid you in focusing your energy and make you a better collage artist over time.

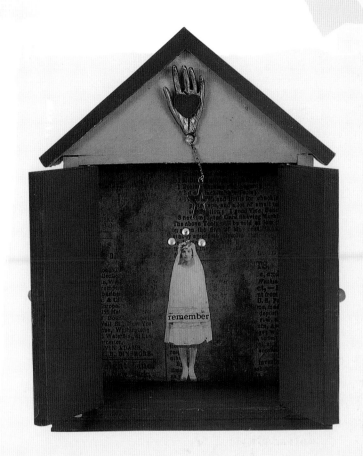

above and facing page << **Remember**
5¼" × 4" × 2" (13.5cm × 10cm × 5cm)
Collage is all about play and pasting materials down and seeing what happens next. This little wooden shrine holds a beautiful collage surprise inside. I used peeling paper in the back of the box behind the little girl and tinted it with a light blue to contrast with the yellow.

tools *and* supplies

★ Basic Collage Supplies

You'll need these basic supplies to get started. You probably have many of these items around the house. If not, these materials are readily available at craft and art supply stores. For ideas about what interesting materials to use in your collage, turn to page 12.

surfaces

The fun thing about collage is that the surface you choose to work on could be just about anything. Many of the techniques that I will demonstrate in this book are done on canvas, but you can easily adapt them to any surface you like.

Personally, I prefer stretched canvas because it can take the abuse that I tend to give out during my art creation process. You might also want to try working on canvas board. It's cheap, small and flat. I don't like it as much, because it tends to buckle, but some people use it and just love it.

Other surfaces that you can collage are candy tins, journal covers, old books, cigar boxes, wooden birdhouses or shrines from your craft store, papier mâché boxes and Masonite. Just about any hard and durable surface will work.

brushes

I am terrible with my brushes. I can hear my art teachers now reprimanding me for the way I treated my brushes! I like to buy the inexpensive ones from the hardware store and just throw them away when they get hard and crusty. I hardly ever buy a brush that's more than a dollar or two. For the projects in this book you'll want some of those flat house-painting brushes that are about 1" (25mm) wide. I encourage you to experiment with various brushes and sizes to see which ones feel best to you.

acrylic paint

I use acrylics for just about all my projects. My favorite acrylic paint to work with is the Golden line of paints. I find their color saturation and quality of paint to be superior to that of other brands. Use fluid acrylics for glazing and layering paints and the heavy-bodied acrylics for general work and texture building.

gel mediums

Gel mediums are basically clear binders that hold the pigments in acrylic paint together. You can use gel medium in a variety of ways. You can add it to your paint to extend the color or to change the look of a paint color from matte to glossy, or you can use it as a gluing agent.

It's the gluing-agent use that made me fall in love with gel medium. All my collage work is created with gel medium; it is the only adhesive that I use. I prefer a matte look to my artwork so I work with Golden's Gel Medium in matte. It comes in a variety of weights, from regular to heavy, and in gloss, semigloss and matte finishes. I use the regular weight for general paper gluing, and I use

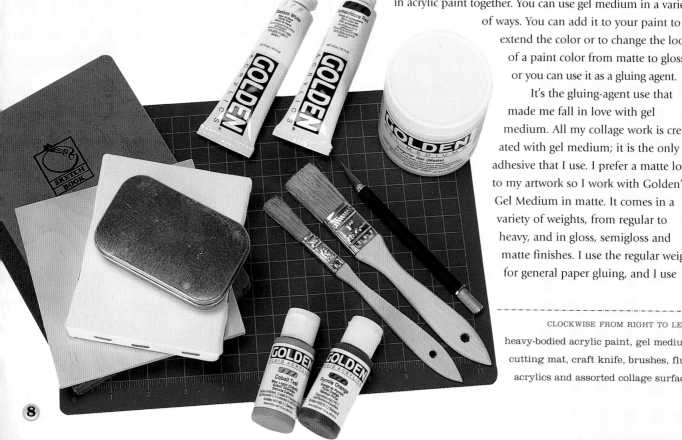

CLOCKWISE FROM RIGHT TO LEFT: heavy-bodied acrylic paint, gel medium, cutting mat, craft knife, brushes, fluid acrylics and assorted collage surfaces

the heavy for assemblage and object gluing. Gel medium is more archival to use than an epoxy type of glue because it will remain flexible and thus will keep your precious object glued down. No cracking off and no clouding or changing of color over time!

cutting tools

You can use scissors to cut most collage papers, but I prefer to use a craft blade and a cutting mat when I have to cut out really small things, such as words out of books.

★ Supplies for Background Techniques

You can quickly create a visually exciting background for your collage by using paper, paint and ordinary household supplies. Turn to pages 20–31 to learn four of my favorite background techniques.

masking tape

For the peeling paper background technique on page 29 you'll need to have on hand some regular masking tape. If you have some in your junk drawer, it should work just fine. I don't use any special brand, just whatever is in the office supply aisle when I go grocery shopping.

bone folder

A bone folder is a flat, polished piece of bone or plastic used to press folds in paper. When I do the peeling paper technique, I rub a bone folder over the masking tape to make the tape stick.

petroleum jelly

I use petroleum jelly and acrylic paint to create wonderful peeling paint effects on my collages. See page 24 to learn more.

★ Supplies for Rusting and Antiquing

You can use a variety of supplies to rust or antique objects to use in your collage. Here are some of my favorites. (See pages 52–59 to learn how to use these products.)

vinegar and bleach

These two household items make a quick solution for rusting tin objects with ease. Wear gloves when you use this solution and work in a well-ventilated space.

commercial rusting products

One of my favorite commercial rusting kits is manufactured by Modern Options. This kit allows you to rust objects that aren't even metal! I have tried quite a few different kits that are out there and this product gives amazing results. You can rust plastic, paper, anything! If you can paint it, you can rust it.

The kit comes with one bottle that is an iron-based paint and another bottle that is a rusting agent, which will rust the iron-based paint. It's a two-step process, but well worth the wait.

patina solutions

A patina solution creates a lovely aged verdigris effect on glass, copper and other surfaces. You can purchase patina solutions at craft stores. I recommend the patina solution from Modern Options.

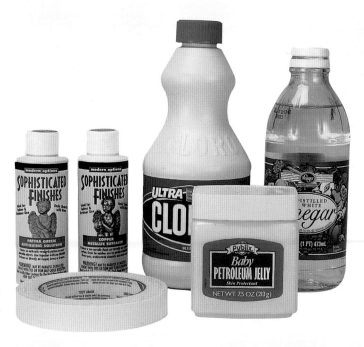

FROM LEFT TO RIGHT:

patina solutions, masking tape, bleach, petroleum jelly and vinegar

★ Supplies for Transfer Techniques

Image transfer techniques give you a variety of clever ways to embellish your collage. Each technique uses a different material and produces a different effect. Experiment with all these materials to see which transfer methods you like best.

caulk

For the caulking transfer technique demonstrated on page 37, I suggest that you use clear Elmer's Squeeze 'N Caulk. It is very important to get clear and not white, taupe or the other colors they offer. I prefer this caulking to others because it is thin and runny and you can brush it on with a paintbrush.

You can also use the regular clear caulking that you have to squeeze out of the can with a caulking gun, but that is a little thick and unwieldy for my taste. Another option is to substitute Golden's Acrylic Gel Medium in Gloss, if you can't find the Elmer's caulk.

heat-transfer tools

To create the heat transfers I demonstrate in this book, you might consider buying a special heat tool. I like to use a little heated transfer tool. This tool is sometimes called a Bunny Burner, named after crafter Bunny DeLorie. You can also use a household clothing iron to create the heat transfers. The iron can be a bit large and difficult to maneuver in small places, so that is why I prefer to use the heat-transfer tool. But, when in a pinch, the regular old household iron will still do the trick!

contact paper

For the tape/laminate transfer technique demonstrated on page 40, you can use either clear packing tape or clear contact paper. You might want to experiment with both to see the different results you get with each one.

★ Tools for Beeswax Techniques

Beeswax is an absolutely magical material to use in collage art. Working with beeswax requires a whole different set of tools from traditional collage, but the results are well worth it! Turn to pages 42–51 to learn more.

beeswax

Beeswax should be available at your local art or craft store. You can also sometimes find packages of beeswax pellets. I really like it when I find the pellets, and I try to snatch up as many as I can! The pellets are really nice because you don't have to bother with breaking up the block of beeswax, which can be difficult at best.

There are two types of beeswax: bleached (also called white) and natural. The natural beeswax has a brownish tint to it and is very lovely, but I prefer the bleached because it is colorless and that way I can tint my beeswax with oil paint to create my own colors.

Do not use paraffin or candle wax for the techniques in this book! It is too brittle and will not hold your collage pieces. You need to use 100 percent beeswax because it is archival and will remain flexible.

small slow cooker

I use a small 16 oz. (473ml) slow cooker (such as a Crock-Pot) to heat beeswax. It is well worth purchasing one for its added safety and convenience if you discover that you enjoy working with beeswax.

irons

For the beeswax techniques beginning on page 42, you will want to use an iron. I use a Samsonite Travel Iron (the one without the holes in the bottom) or a tiny little quilting iron with a triangle shaped head. You can find the quilting iron in fabric or craft stores.

rubber stamps

For the wax stamping techniques on page 50 of this book, you will want to use deeply etched stamps, almost like woodcuts. Metal punch stamps work well for wax stamping,

FROM LEFT TO RIGHT: heat-transfer tool, packing tape, colored pencils, caulk and contact paper

too. The photo-type stamps with a lot of detail but little depth do not work well for wax stamping.

oil paints

The only time you'll find me not using acrylic is when I am working in wax. For wax projects it is best to use oil-based paints.

I prefer to get oil paints that clean up with water. A few companies make water-soluble oil paints, and I find them so much easier to use than the traditional oil paints. You can clean up with soap and water instead of having to use turpentine or mineral spirits. Look for them at your local craft store or art supply store.

heat (embossing) gun

I use a heat gun all the time when I work with beeswax. A heat gun set on high is a useful tool to liquefy the wax on your collage, making it possible to manipulate the surface. It can also help blend stiff or dry brushwork in wax.

nail polish remover

Purchase nail polish remover with acetone to create easy image transfers on beeswax.

crayons

Children's wax crayons are perfect for adding color to a beeswax collage. You can drip melted wax on the collage surface or blend the colored wax in with an iron or heat gun.

★ Framing Tools

You can create an inexpensive wooden frame or shadow box for your collage with a few basic tools from your local home improvement store. Making your own frames can save you a lot of money and make your artwork look its best. See page 16 for instructions.

Here's what you'll need:

- Miter box
- Saw
- Tacking nails
- Hammer
- Spackle
- Spatula
- Sanding block
- Long strip of wood molding

★ Safety Precautions

1. Don't eat while painting.
2. Be aware that many products are not for use by children.
3. When trying the rusting techniques in this book be sure to work outside in a well-ventilated area and wear a mask. The fumes can be caustic.
4. Use caution when working with the heat tools and beeswax supplies.

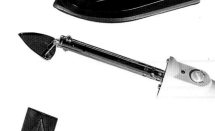

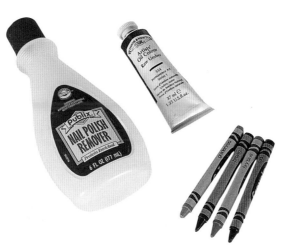

FROM LEFT TO RIGHT: slow cooker, beeswax, nail polish remover, oil paint, crayons, rubber stamp, quilting iron, travel iron and heat gun

finding materials *for collage*

Half the fun of making a collage comes from gathering the materials that go into it. Antique stores, secondhand bookshops and flea markets are great places to start. Closer to home, there are dozens of other places where you can find interesting items to use in your collages or assemblages. Dollar stores, hardware stores, office supply stores and thrift stores are just some of the places you can find materials.

If you don't have much time to shop, ask your friends who love antiquing to find supplies for you. Remember, you don't need to hoard tons of stuff. Buy a few items, use them and when you run out, go and buy some more. People assume that I must have tons and tons of stuff piled up in my home. I don't! I find that 90 percent of the fun comes from using the items I have and then going out and getting more!

The following list includes places you might not think of at first as a place for discovering collage materials. Keep your eyes open. Everywhere you go, marvelous items are waiting to be discovered. Here are some of the items that might inspire you:

> The sources for collage materials are almost limitless. Keep your eyes open wherever you go and wonderful materials will present themselves to you.

CRAFT STORE OR FABRIC STORE:
- Fabric, lace, tassels
- Beads
- Buttons
- Brass charms
- Cord, yarn, ribbon
- Precut tin shapes (choose tin, not aluminum, if you want to rust them)

SECONDHAND BOOKSTORE:
- Antique book pages
- Maps
- Dictionary pages
- Documents
- Clip art books

ANTIQUE STORE:
- Old letters
- Old tape measures or yardsticks
- Keys
- Coins
- Vintage photos

- Eyeglasses or magnifying glasses
- Medical tools
- Old pencils and pens
- Postcards
- Old stamps
- Memorabilia

DOLLAR STORE:
- Playing cards
- Word puzzles and other games
- Rubber stamps
- Matchboxes
- Gift wrap
- Interesting children's toys
- Boxes for assemblage
- Dominoes, dice
- Game pieces
- Dolls

OFFICE SUPPLY STORE:
- Various tags, manila tags and jewelry tags
- Date stamps, office stamps

- Star stickers
- Brown packing paper
- Twine
- Boxes
- Interesting papers
- Envelopes
- Alphabet stencils

OUTDOORS/NATURE:
- Shells
- Driftwood
- Bones
- Feathers
- Leaves
- Pressed flowers

THRIFT STORE:
- Doll clothes
- Dolls and doll parts
- Old toys and game pieces
- Cigar boxes for assemblage
- Old photos
- Trophies

- Shoes
- Lace
- Dress patterns
- Books
- Purses
- Ties
- Belts and belt buckles
- Plates, cups and saucers
- Cooking utensils
- Forks, knives and spoons

HARDWARE STORE:
- Washers
- Nails, screws
- Hardware cloth
- Wire and wire screening
- Extra paint (pick up the returns of mismatched colors)
- Wood scraps
- Wood molding
- Paint chip samples

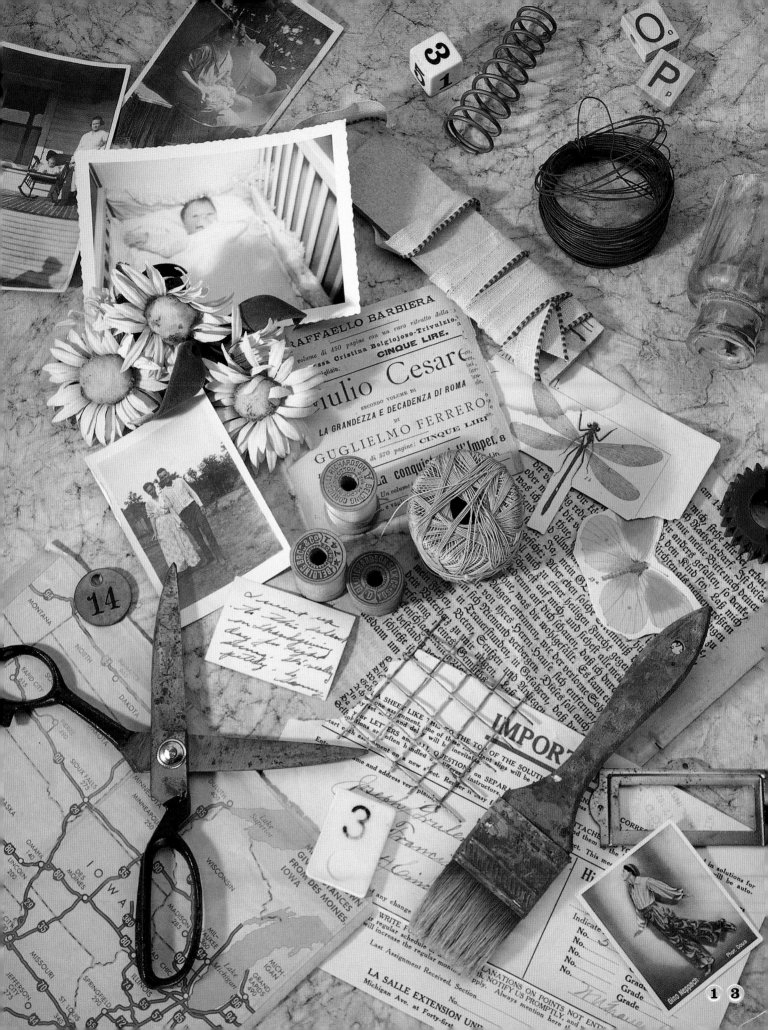

basic techniques

ONE OF THE GREAT THINGS ABOUT COLLAGE IS THE SIMPLICITY OF IT. Much of collage uses the same cut-and-paste skills you probably learned in grade school. Still, I would like to share a few pasting techniques that will assure that your pieces don't curl or come apart over time. There are also tips on how to frame your finished work.

Collaging Papers and Small Objects

To begin, I recommend you use matte acrylic gel medium as the "glue" to create your collages. From start to finish, I have found no other material that can multitask as well as gel medium can! You can glue everything from papers to small objects (such as dice, dominoes and marbles). It won't age, crack or yellow like other glues can. I love it.

Many people ask me how I get my papers down onto my canvas without getting bubbles. The answer is a little bit of luck and some practice! I'll show you my little trick, and then you can see if it helps you, too.

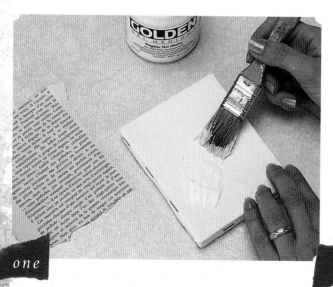

one
Coat the Surface with Gel Medium

Prepare your art surface by coating it with a thin layer of acrylic gel medium.

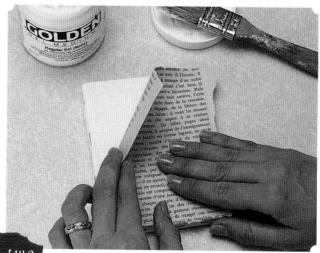

two
Position the Paper to Collage

Cut out the image you would like to collage. Place your image into the wet gel on the art surface.

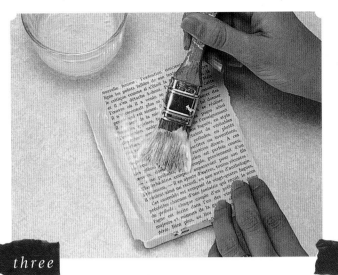

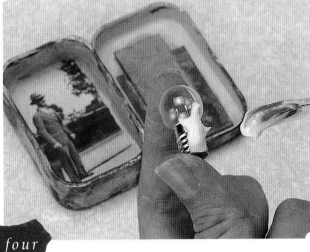

three

Coat the Item With More Gel Medium

Brush over the image with another layer of gel medium from the center outward, using the brush to press down and smooth any bubbles.

If you see a bubble, leave it alone! Nine times out of ten, it will flatten as the paper dries. Sometimes I fuss with my bubbles and I always regret it, because I create a bigger mess than if I had left it alone!

four

Attach Additional Objects

You can glue down anything with gel medium, from buttons, to small glass bottles, to heavy metal keys. Brush a big blob of gel medium onto the back of the object, then set it onto the surface and apply a little pressure. With a clean paint brush, wipe away any excess gel that seeps out the sides. Wait for the gel medium to dry and your object will be on there to stay.

{Copyright and Ethics} IN collage

If you are interested in working in collage, then copyright is something that you should be aware of. Even if you are just a weekend or hobby artist, it doesn't mean that you can't avoid attention to copyright and ethical use of materials in your collage creations.

Many myths are floating around, which a person new to copyright may assume are true. One that comes to mind, in particular, is the myth that if you alter an image "enough," it's "OK" to use it. This is not true. Just because you slightly alter another artist's artwork, doesn't make it acceptable to use.

On top of all these myths out there, it's even more difficult to get clear answers, and when you finally do manage to get to the actual law to read it yourself, it is murky and confusing to understand.

If you want to be informed, I would advise you to consult the following resources. Both are easy to read and will give you a clear idea of how you can create collage but still be ethical in your art making.

`Copyright for Collage Artists` This is a great Web site to visit if you have any questions about copyright. Sarah Ovenall answers your questions in an informative and chatty style. Easy to read and easy to understand. www.funnystrange.com/copyright/index.html.

`The Public Domain: How to Find & Use Copyright-Free Writings, Music, Art & More` By Attorney Stephen Fishman. ISBN: 0873374339. This book is a great source to make sure the papers and elements you are using are copyright free. It has checklists and directions to follow to be sure you are using available materials.

Framing Your Collage

Once you've created a collage that you're really happy with, you might want to consider framing it. This framing technique works on collages that are made on wood or stretched canvas. You might want to keep that in mind when choosing a surface to collage. A frame will make your collage look its best.

I make this frame out of lattice molding. You can find lattice molding in the molding section of your local hardware or home improvement store. It comes in 16' (5m) strips. Ask an assistant to cut it down for you so you can fit it in your car. Since lattice molding is so inexpensive, I like to call this the "seventy-five-cent frame." That's about what it costs to frame an 8" x 10" (20.5cm x 25.5cm) piece, and you can't beat that!

This framing method doesn't require any expensive power tools. I hate power tools. I try to use as few of them as possible in my life. Fortunately, you can make this frame with a simple handsaw and miter box. You can often buy them packaged as a set at your local hardware store. Another benefit to this technique is that there is no measuring with a ruler, either. I am terrible at measuring, so I devised a way to avoid it, too!

you will need

a strip of lattice molding ✳ handsaw ✳ miter box ✳ hammer ✳ small tacking nails ✳ lightweight spackle ✳ paint scraper ✳ sandpaper ✳ acrylic paint ✳ paintbrush

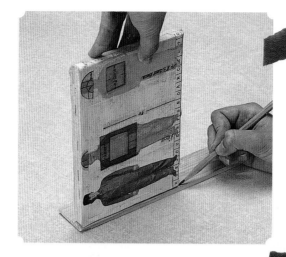

one

Measure the Sides

Lay the short side of your canvas on the lattice and mark the end of it with a pencil.

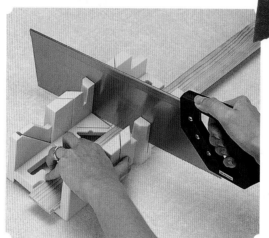

two

Cut the Side Pieces

Put this end in your miter box. Place your saw in the 90° angle slot, so you are making a straight cut and not a mitered cut. Cut this piece of wood. Then use the cut piece to measure out another cut on the lattice molding. Cut that piece, too. You should now have two short pieces of wood that each fit the short sides of your canvas.

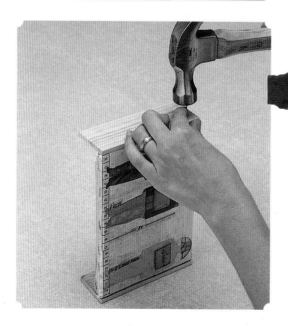

three

Nail the Side Pieces

Nail both strips to each short end of your canvas flush with the front of the canvas. You now have a canvas with two wood pieces attached to it.

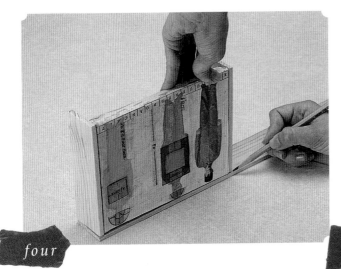

four

Measure the Long Sides

Now you need to measure the long sides. Place your first long side flush with one end of the lattice molding and mark where the canvas and newly attached wood pieces end. Then cut that strip of molding. Use it to measure and cut a piece the same size for the other side.

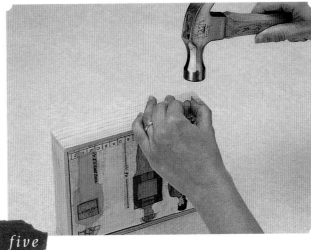

five

Attach the Long Pieces

Nail both of your long pieces to either side of the canvas.

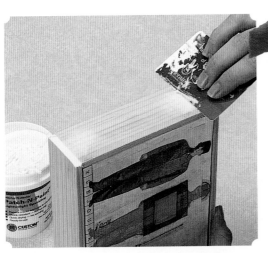

six

Seal Any Gaps

You might notice that your wood frame has some flaws in it, or you might not have cut the wood perfectly. Don't despair! Just use spackle and no one will ever notice. Apply spackle liberally, using a paint scraper or an old hotel key card.

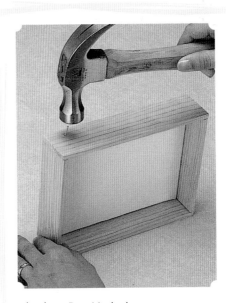

Shadow Box Variation

Using the same concept as the seventy-five-cent frame, you can create your own shadow box. Instead of nailing your wood pieces aligned with the front of the canvas, simply nail the wood flush with the back of the canvas instead.

I love being able to create my own boxes. They are cheaper than the ones you might buy at the store, and you can customize them to your size needs. Also, by using canvas as the back to the box, you can sew through the background and add objects and elements in interesting and surprising ways.

seven

Sand the Frame

When the spackle is dry, give it a light sanding to make it nice and smooth. Brush off any spackle dust. Now you can paint your frame using acrylic paints and you are done! An inexpensive frame that looks amazing!

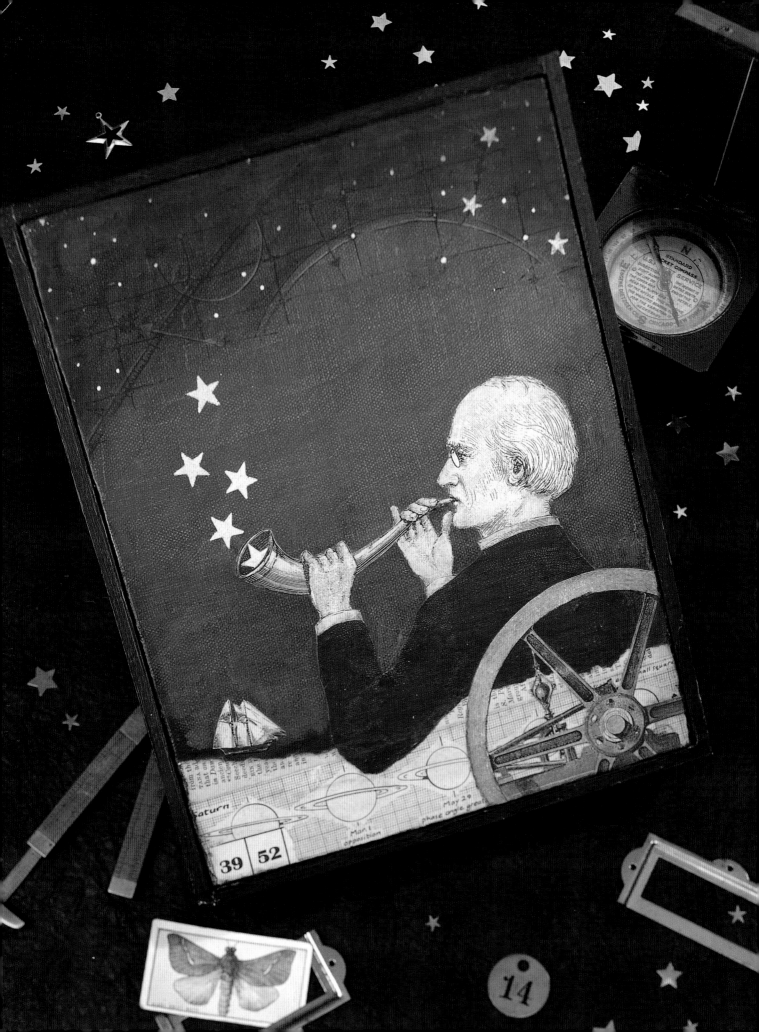

creative *collage techniques*

This first section is a recipe book of fifteen of my favorite collage techniques. They cover everything from creating luscious backgrounds to making image transfers, working with beeswax and antiquing objects for assemblage. The purpose of these techniques is to teach you how to use ordinary collage elements in new and exciting ways.

These techniques are like building blocks. Try the ones that capture your interest, then mix them together and see what happens. You may discover, as I did, that what starts as an experiment may blossom into a collage-making frenzy!

Collage thrives on serendipitous discoveries; sometimes you are not sure if you are creating the artwork or if the artwork is actually creating itself. So approach these techniques with a sense of play and exploration. You can't possibly make any mistakes here, only discoveries.

When elements fall together just right, it feels like magic!

> "I don't go into the studio with the idea of 'saying' something. What I do is face the blank canvas and put a few arbitrary marks on it that start me on some sort of dialogue."
>
> **RICHARD DIEBENKORN**

facing page << **The Star Maker** 10½" × 8½" (26.5cm × 21.5cm)
The right mix of techniques can create a magical effect in a collage. In this piece, I created the deep blue sky using the glazed paint background technique. Then, I used the heat-tool transfer method to add the celestial map on top of it.

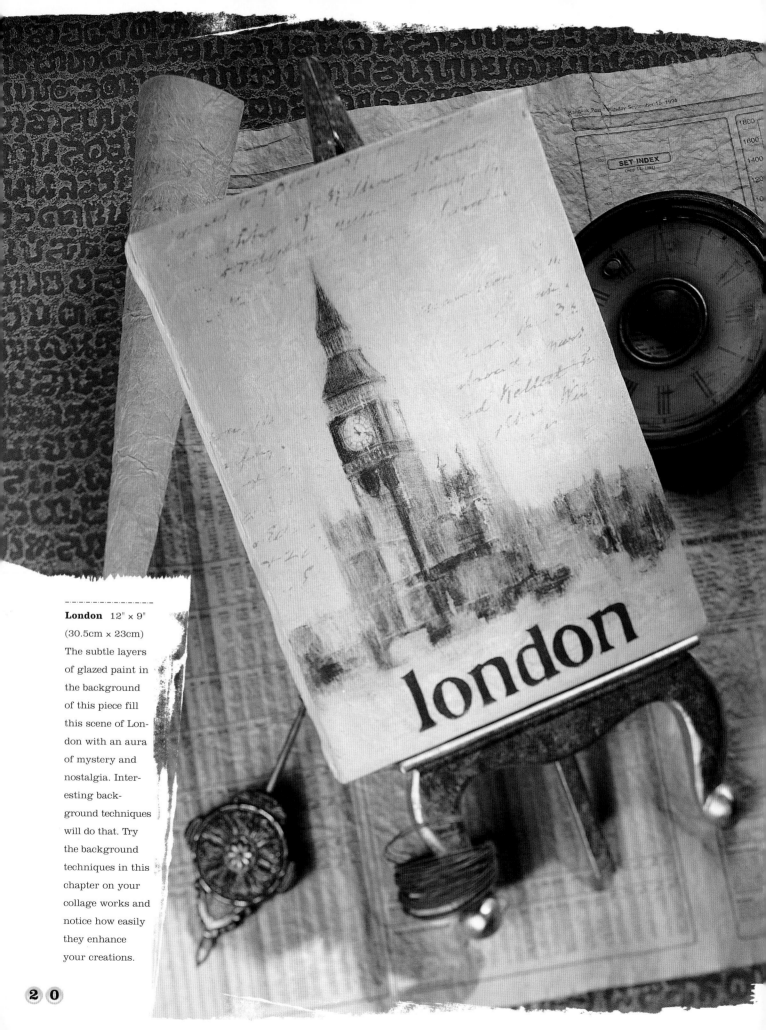

London 12" × 9" (30.5cm × 23cm) The subtle layers of glazed paint in the background of this piece fill this scene of London with an aura of mystery and nostalgia. Interesting background techniques will do that. Try the background techniques in this chapter on your collage works and notice how easily they enhance your creations.

CREATING *backgrounds*

Your mind is totally blank, and it looks as if you're never going to have another good idea again.

First thing is to take a deep breath. You've got plenty of amazing ideas in your head; you just can't see them right now because all that is looking at you is a glaring white, blank canvas.

So you're about to start a new collage and you don't know where to begin.

Fear not. This section teaches you how to create four eye-catching backgrounds. Backgrounds are my way of attacking the "blank canvas" syndrome. Work on these background techniques with no thought whatsoever as to what might go on top of them. Before you know it, you'll have created a beautiful surface that is just begging for images to go on top of it. And it's no longer a scary blank canvas!

Do not worry about what theme or collage elements you might put on top. All these background techniques can be intermixed, used on top of each other and much more. Experiment and see what happens! You'll soon notice that a background starts to guide you in an interesting direction. It is almost as if the artwork is creating itself!

glazing paint

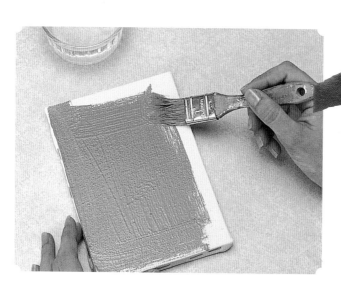

GLAZING PAINTS SOUNDS MORE COMPLICATED THAN IT IS. Glazing is just a fancy way to describe creating a wash with a thin layer of paint.

I often use glazing to give my backgrounds depth and to create jewel-like colors. Using paint straight from the tube will give you a nice color, but if you layer a few glazes over the paint, you can create an amazing color!

When one transparent color is applied over another, the top color alters the first. This is because light rays mix, creating a visual color mixture. Great depth and beauty can be achieved by using a few layers of transparent color over your original base color.

 you will need

art surface; this could be canvas, wood, paper, a journal cover or other surface ★ acrylic paints ★ paintbrush ★ paper towels ★ water jar

one

Paint the Base Color

Paint your canvas a solid color. In this case I chose Cobalt Teal. Allow the paint to dry or dry it with a heat gun.

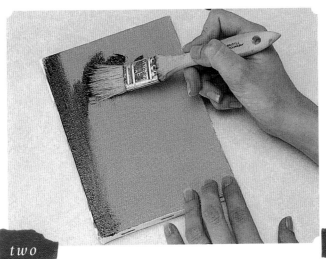

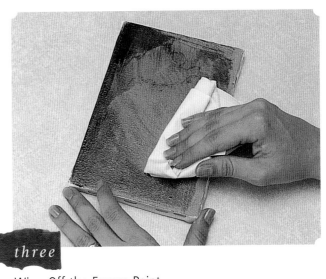

two

Add a Second Color on Top

Brush a darker color thinned with water over the base color. I used Turquoise Phthalo.

three

Wipe Off the Excess Paint

Before the top layer of paint dries, wipe off most of it with a paper towel and you've created a glaze.

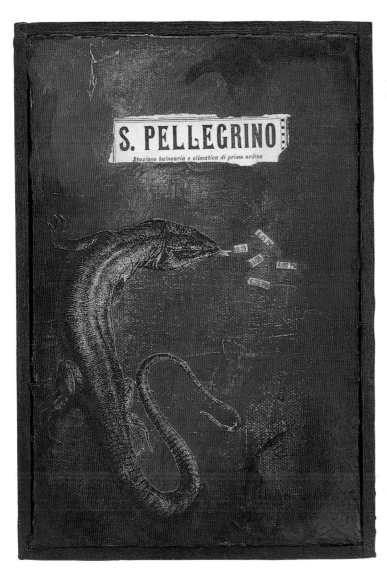

★ **helpful hint** Glazing is also a wonderful way to enhance texture in your backgrounds. Apply a glaze over a textured surface. It will sink into the grooves and bumps and show off this surface to an advantage.

Five Moments in Time
9½" × 6½" (24cm × 16.5cm)
This collage is an excellent example of the magic created by a glazed paint background. I began with a dull red background, which I glazed over in a darker red, wiped it off and allowed it to dry. Next, I glazed in areas of Burnt Umber to add even more depth to the background.

peeling paint

you will need

art surface ★ acrylic gel medium (if you are working on paper) ★ paintbrush ★ two or more colors of acrylic paint ★ petroleum jelly ★ heat gun (optional) ★ paper towels ★ soap and water

ONE OF MY FAVORITE BACKGROUNDS IS THE PEELING PAINT LOOK. I usually end up with this type of background while working on an artwork that isn't going quite right. I paint over part of the canvas, then sand it, then paint it again and sand it some more. The result is an interesting layered paint effect.

If you don't want to spend days building up layers of paint only to sand them off, you can force the paint to peel with the magic of petroleum jelly.

Before you start, paint your art surface with a thin basecoat of color. You could also use paper adhered to your surface as a starting point. Just make sure you water-proof it with a layer of gel medium before applying the petroleum jelly, otherwise the paper will soak up the grease from the jelly and the technique won't work properly.

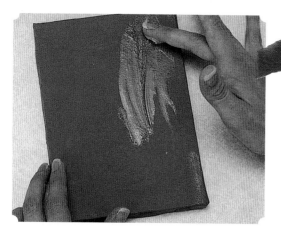

one

Coat Part of the Surface With Petroleum Jelly

When your basecoat of paint or collage is dry and sealed, take a few fingerfuls of petroleum jelly and rub it here and there on your art surface. You want to be a little thick with the jelly, like buttered bread, but with no huge globs or "peaks." Practice will help you find the perfect amount.

Keep in mind that wherever you put the jelly the paint will peel off and your background will show through.

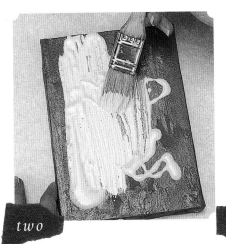

two

Paint Over With Acrylic Paint

Once you have jellied your art surface, coat the entire piece with your favorite color of acrylic paint. If you are using tube acrylics, thin the paint with water first, until it is the consistency of chocolate syrup. You want it to flow over the jelly without mixing into it. It may feel very strange to be painting over petroleum jelly, but you'll get the knack of it.

Dry the surface with a heat gun if you are in a hurry, or simply set it aside and wait for the paint to dry.

three

Wipe Off Loose Paint With a Towel

Once all the paint is dry, take a paper towel and rub it over the canvas. You'll see the paint easily lift away from the background where the jelly was applied. If you have an area that isn't lifting as easily, scratch at it with your fingernails or sandpaper.

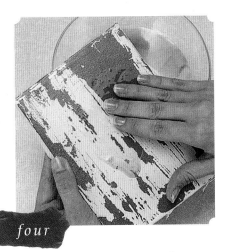

four

Wash Off the Remaining Jelly

When you are satisfied with the amount of peeling, you'll need to get rid of the greasiness so that you can collage over the surface. Take your artwork to the sink and gently wash it with a little soap and water. Don't worry, you won't hurt it. If you are working on the pages of a book, you can use baby wipes to get rid of the grease; that way you won't ruin the delicate pages.

⭐ **helpful hints** You might want to add more paint to this surface to even out the peeling look and make any adjustments until you are happy with your background. You can do the peeling paint method again with a different color, for an even more layered effect. Also, try using thicker and thinner areas of petroleum jelly; you'll notice it will create various peeling effects.

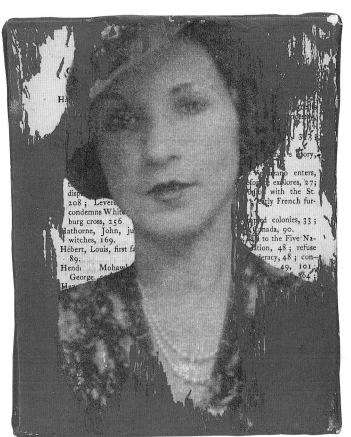

Belle 5" x 4" (12.5cm x 10cm) This piece was an almost finished collage, but it looked like it was missing something. It needed just a little touch extra to make it work. I decided to do the peeling paint technique on top of the whole piece. It added a weathered effect to the collage and completed the artwork.

textured paint

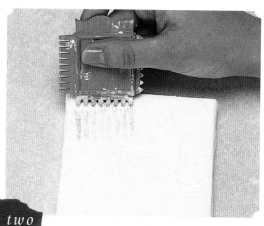

★ *you will need*

art surface; this could be canvas, wood, Masonite, journal pages, etc. ★ heavy-bodied white acrylic paint or gesso ★ tools to manipulate paint: old credit card, palette knife, comb, rubber stamps, pens ★ acrylic paint: Titanium White, Yellow Ochre, Pyrrole Orange and Transparent Red Iron Oxide ★ paintbrush ★ water ★ paper towels

★ why not use spackle?

I like to use acrylic paint for this method rather than spackling or modeling paste because acrylic paint is not absorbent. It will allow for more manipulation when glazing other paint colors on top. Also, acrylic paint is much more flexible and has less risk of cracking than spackle.

ANOTHER ONE OF MY FAVORITE BACKGROUNDS IS CREATED WITH TEXTURED PAINT. For this technique, you will want to look for thick acrylic paint that comes in a jar or a tube. The paint needs to be about the thickness of sour cream; this is sometimes called "heavy-bodied" paint. You can also use acrylic gesso for this technique.

The following demonstration shows four different ways to texture paint all on one surface. When texturing paint in your own collage, you can choose whichever of these techniques works best with your design.

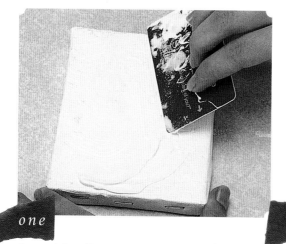

one

Spread Acrylic Paint Across the Surface

Squeeze a big glob of white acrylic paint directly onto your canvas. Smooth the paint around to create almost a stuccolike texture. Here, I am using an old hotel key card.

two

Texture the Surface With a Comb

Comb areas of paint with a combing tool. This tool is good for making checks, wavy lines and stripes.

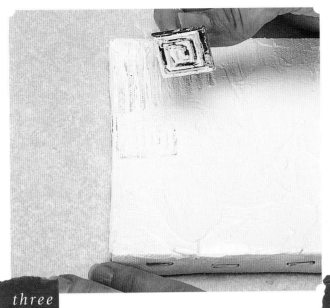

three

Stamp the Surface With Stamps

Using deeply etched stamps with simple designs, stamp the surface. Finely detailed stamps will not work.

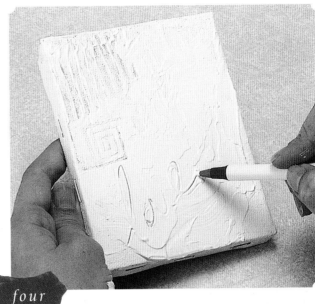

four

Write in the Paint With a Pen

Write or draw on the surface with a pen. Loose looping script looks good.

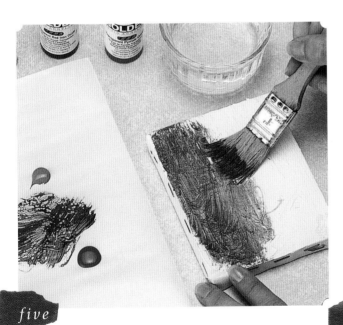

five

Add a Wash of Paint

Allow your art surface to dry (usually overnight or for a few hours with the aid of a heat gun). Add a wash of color. Here, I am using Yellow Ochre, Pyrrole Orange and Transparent Red Iron Oxide thinned with water. Smooth it all over the surface with your brush.

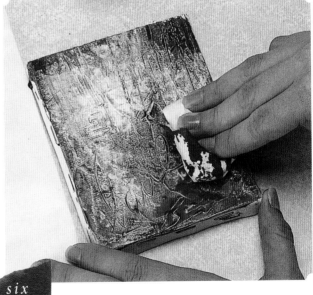

six

Rub Off Excess Paint

Before the paint dries, wipe off the excess paint with a towel. You'll notice the remaining paint has sunk into all the wrinkles and grooves that were created in the white paint. The background is already starting to look really nice!

>> **TURN THE PAGE TO FINISH THIS TECHNIQUE**

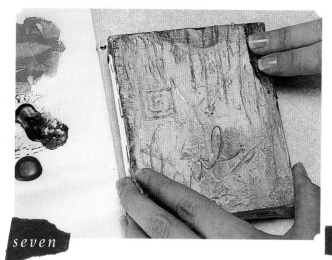

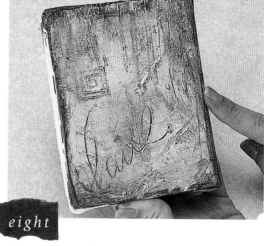

seven

Add More Color

Add more color with your fingers. Fingers are my favorite tools. Don't be afraid to use them!

eight

Deepen the Color Around the Edges

Run a deep color around the edges to finish the effect. I find that edging the canvas with a dark rim really helps finish it and set it off nicely.

★ **more fun with texture**

Experiment and see what other kinds of textures you can create with simple items from around your home! Here are a few examples of other techniques to try:

>> Scrape the paint with a palette knife or serrated plastic knife.

>> Try sprinkling your paint with sand.

>> Mash tissue paper or objects into the wet paint.

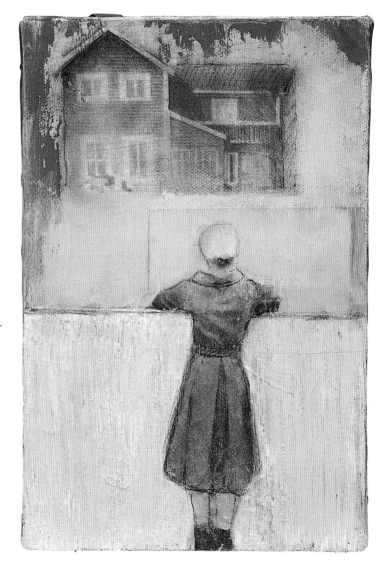

Our House 8¾" x 6" (22cm x 15cm) In this artwork I used the textured paint technique to create a fence-like element behind the girl. I also used peeling paint at the top of the artwork with green paint.

peeling paper

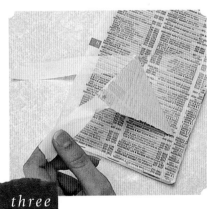

you will need

art surface ★ sheet of paper from an old book, map or newspaper with text on both sides ★ acrylic gel medium ★ paintbrush ★ masking tape ★ bone folder ★ acrylic paint ★ water ★ paper towels

THE PEELING PAPER BACKGROUND IS A QUICK AND SIMPLE WAY TO ACHIEVE AN AGED AND ANTIQUED-LOOKING BACKGROUND USING JUST ABOUT ANY KIND OF PAPER. Here, I'll show you how you can make even a phone book page look good!

The amazing thing about this method is you will get a large amount of variation in what layers of the paper peel up and what parts stay glued to your surface. When this method is combined with a wash of acrylic paint, you can get some really incredible-looking aged surfaces in a short period of time.

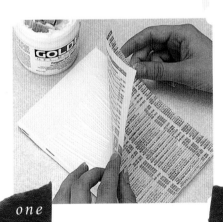

one

Glue Paper Onto the Art Surface

Brush a layer of acrylic gel medium onto your art surface. Lay your sheet of paper on top of the gel medium and press it down. Do not brush any gel medium on top. Take note of what's on the back of what you're gluing down because this may show through later in surprising ways.

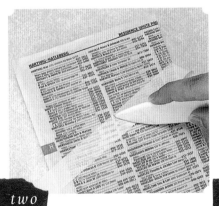

two

Stick Masking Tape on Top

Allow the glued paper to dry for about two minutes, then take a strip of manila masking tape and stick it firmly to the surface of the paper. Burnish the tape with a bone folder to make sure it's really sticking.

three

Peel Off a Section of Paper

Pull up on the tape and you'll notice some of the paper will start to pull up. Pull the tape in different directions to affect how much paper comes off and how much stays on.

>> TURN THE PAGE TO FINISH THIS TECHNIQUE

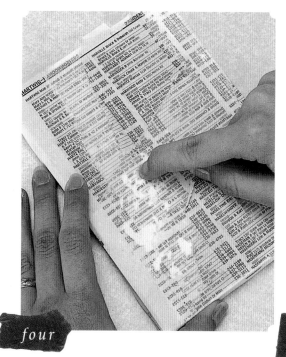

Scratch Off Other Sections of Paper

Continue to apply new pieces of tape to your surface and peel them off. Scratch off additional sections using your fingernails. Almost right away you can see the interesting background that this is creating!

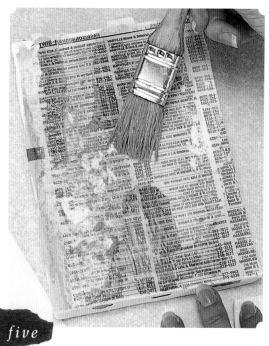

Paint the Surface With a Wash of Color

After you are done peeling the paper, it is sometimes nice to cover the surface with a wash of acrylic paint thinned with water. As you brush on the watery paint, you'll notice that the paint will adhere darker to the exposed paper areas and will create an interesting and aged-looking background.

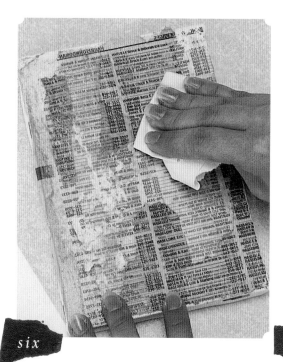

Lift Off Excess Paint With a Towel

Blot some spots with a paper towel to lift up color and create a more varied background.

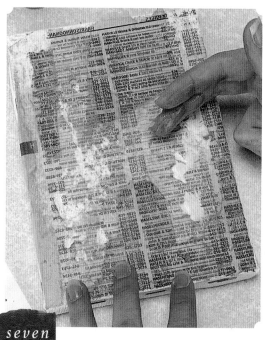

Add Accent Colors to the Background

To finish the background, use your fingers to dab some areas of the surface with a corresponding color.

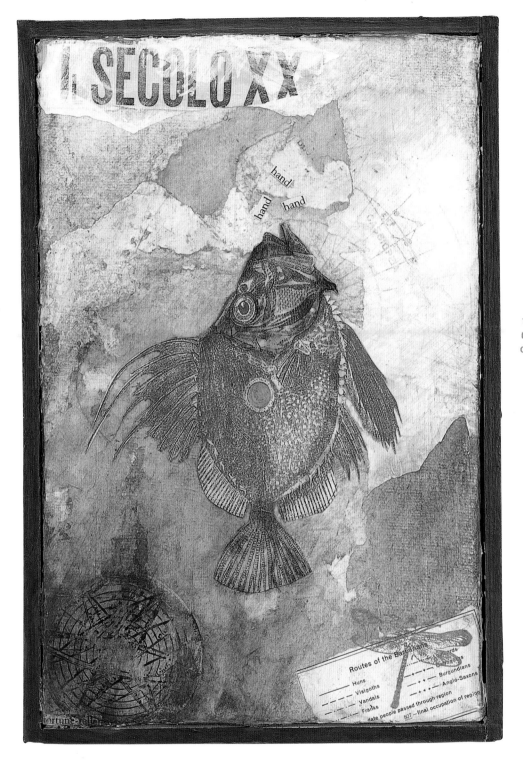

The Aquarium 9½" × 6½" (24cm × 16.5cm)

In this artwork I used plain white copier paper to create the peeling paper background. After I had finished peeling the paper strips, I gave the background a wash of blue and green paint to create the underwater look that I wanted.

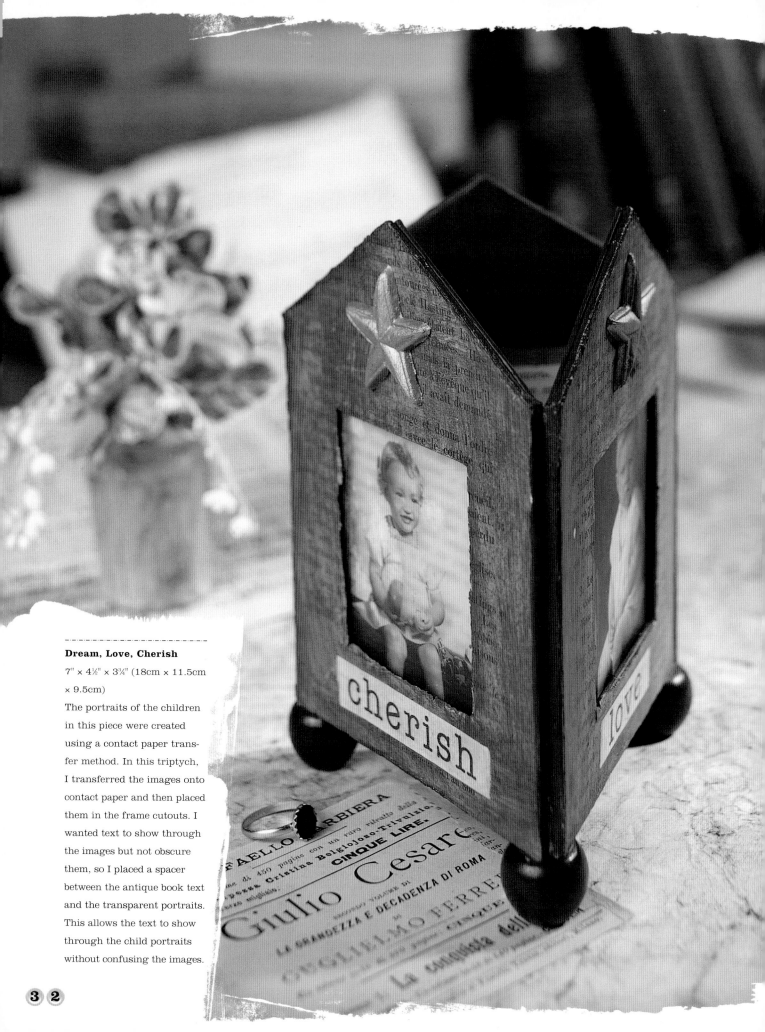

Dream, Love, Cherish

7" × 4½" × 3¾" (18cm × 11.5cm × 9.5cm)

The portraits of the children in this piece were created using a contact paper transfer method. In this triptych, I transferred the images onto contact paper and then placed them in the frame cutouts. I wanted text to show through the images but not obscure them, so I placed a spacer between the antique book text and the transparent portraits. This allows the text to show through the child portraits without confusing the images.

MAKING *image transfers*

In this section, I will teach you three of my favorite techniques for transferring images such as vintage photos, written words or clip art onto wood, glass, paper and other collage surfaces.

Simply put, transfer techniques let you transfer an image from one surface to another.

While I was teaching at a workshop recently, a student asked me, "Why would anyone want to do a transfer as opposed to just gluing down an image?" Good question! The best reason is that a transferred image is transparent, which means it will allow the background of your artwork to show through. It's a great way to create more depth and interest in your collages.

Before jumping in and creating a transfer, you first might want to think why you would like the image to be transparent. Keep in mind that whatever background elements you have on your surface will show through your transferred image. If you have a busy or a dark background, this might not be the best situation to use a transfer. I find that transfers work best on semisolid and light-colored backgrounds.

Transfer techniques are also helpful when you want to use an image that has a lot of intricate parts that would be difficult to cut out or trim away from the paper. In that case, I often opt to use a transfer rather than slaving away with my craft knife for hours on end.

Before you begin, make photocopies of the images you want to transfer. All these techniques use black-and-white photocopies or color laser copies. Once you try each of these image transfer techniques, you'll want to use them on everything. Each method has its positive aspects; it's up to you to discover which one you enjoy incorporating into your projects the most.

heat transfers onto glass

USING HEAT IS A SIMPLE WAY TO GET AN IMAGE TO TRANSFER. Patience is needed with this transfer method, but it does have its advantages. You can use it on glass, mat board, wood, some metals, journal pages or fabric—all without having to wait for glue to dry or using smelly solvents!

I use a heat-transfer tool with a small, round end for this technique, but a regular clothing iron or a small quilting iron will also do the trick! Just put the iron on maximum heat and you'll be ready to go. I prefer a heat-transfer tool, because it is smaller and easier to manage.

This technique is best suited for small- to medium-sized projects. If you would like to transfer an image larger than about 5" x 7" (12.5cm x 18cm), you might want to try one of the other transfer methods in this chapter.

you will need

black-and-white photocopy or a color laser copy (ink-jet prints will not work) ★ heat-transfer tool ★ glass surface to transfer your image to (I used an optician's lens.)

★ **before you begin** When transferring an image onto glass, you need to allow your heat-transfer tool to heat up directly on the glass, to avoid cracking the glass with the heat of the tool. Plug in your tool only when you are ready to start rubbing the back of the paper.

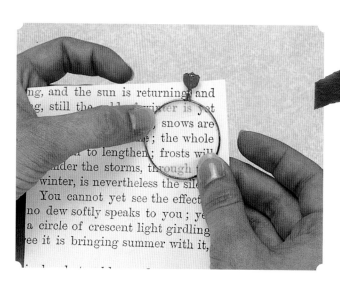

one

Choose an Image to Transfer

Use your optical lens or glass surface as a composition finder to choose images or words you would like to transfer.

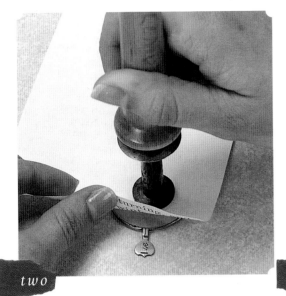

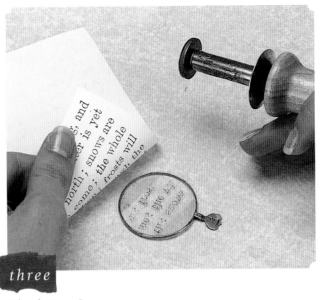

two

Heat the Back of the Image

Place the paper with your image facedown onto the glass. Place the heat-transfer tool on the back of the paper and plug the heat tool in. Slowly rub over your image in small circles over and over again. Heat one small area at a time.

three

Check Your Progress

Lift and check to make sure that your printed image is transferring properly. Continue lifting, checking and heating until you can see that the image has completely transferred to the glass.

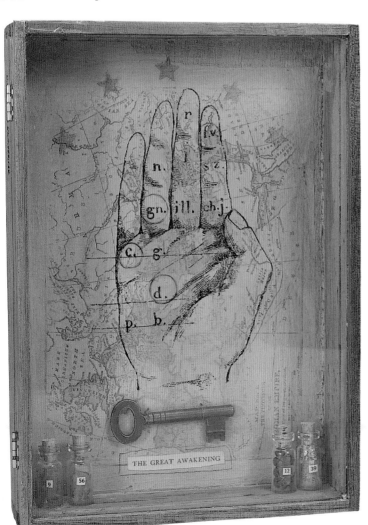

★ **fixing mistakes** If you do your transfer on glass and accidentally mess up the transfer, you can use nail polish remover to remove the image and start over. If your image sticks to the surface and is hard to remove, just heat it up a little bit with the heat-transfer tool and it will easily peel off.

The Great Awakening

10½" x 7½" x 2" (26.5cm x 19cm x 5cm)

Here, I used the heat tool to transfer the hand image onto a glass window placed over a cigar box. By transferring the hand onto the glass, it adds a nice three-dimensional shadow effect that completes the assemblage.

heat transfers
onto wood

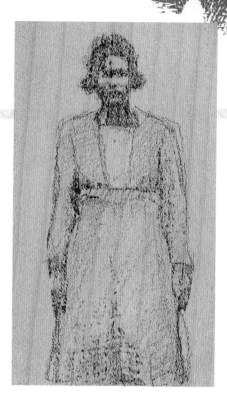

you will need

black-and-white photocopy or a color laser copy (ink-jet prints will not work) ★ scissors ★ heat-transfer tool ★ art surface ★ colored pencils (optional)

THIS EXAMPLE IS DONE ON WOOD BUT, YOU CAN ALSO TRY THIS METHOD ON PAPER OR FABRIC. Just choose a surface with a background color light enough that the image will show up on top of it.

Unless you are transferring to glass, this technique reverses your copied image. If your copied image has text on it, the text will be backwards after transferring. Most copier machines have the ability to reverse the image you would like to copy. Have your copies reversed before you transfer them and then they will transfer the correct way.

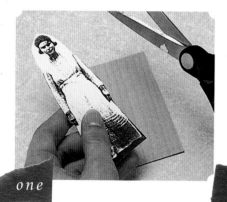

one

Cut Out the Image

Plug in your heat-transfer tool or household iron, and wait for it to heat up. It should heat up in a matter of minutes. Be careful, because it will be very hot! In the meantime, cut out a photocopied image to fit the wood surface.

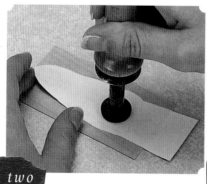

two

Transfer the Image

Place your image facedown on the wood. Heat the back of the paper with the heat-transfer tool. Press hard and lift a corner periodically to check the progress of your transfer. Continue lifting and checking until the image has completely transferred.

three

Add Details With Colored Pencils

After you have finished transferring your image, you can add color and details with colored pencils.

caulking transfers

★ *you will need*

black-and-white photocopy, color laser copy or ink-jet printout ★ Elmer's clear Squeeze 'N Caulk ★ art surface ★ paintbrush ★ water ★ sanding block ★ colored pencils (optional)

★ ink-jet prints or color copies?

At many of my workshops, students have asked me if caulking transfers work with ink-jet prints. Ink-jet prints will work with this method, but you might not want to use them, as they are not lightfast and can fade dramatically in as little as two weeks. You're better off using regular photocopies or color laser copies. While they are not perfectly archival either, they are much more stable than ink-jet prints.

THIS TRANSFER TECHNIQUE IS PERFECT FOR LAYERING DETAILED OR LARGE IMAGES ONTO YOUR COLLAGE. It is a little less labor-intensive than the heat tool method, but you do have to wait for the caulking to dry.

Even when using the same image, heat transfers and caulking transfers will produce somewhat different results. Be sure to try both techniques and see which effect you like best.

Remember, if your image has text on it, reverse it on a photocopier first, before you make your transfer. Then text will transfer the correct way.

one

Squeeze Caulking Onto the Surface

Squeeze the caulking compound directly onto your collage surface. In this example, I chose a canvas that was covered with an antique map, then painted over with a thin coat of cream-colored acrylic.

two

Brush Over the Entire Transfer Area

Brush the caulking out to smooth it. Cover the entire area where you want to transfer your image. Don't worry if you have excess outside your transfer area.

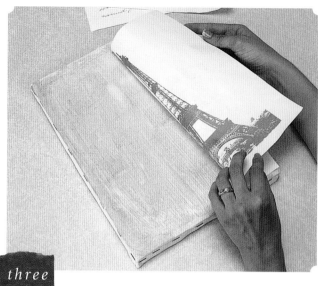

three

Place Your Image on the Caulking

Place your image facedown onto the wet caulking. Gently smooth the image out. Be careful not to get any caulking on the back of the image. Set aside the artwork to dry. For best results, allow the caulking to dry for twenty-four hours.

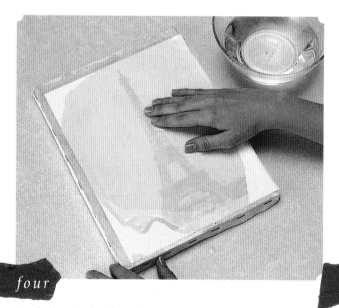

four

Soak the Back of the Paper

When the caulking is dry, wet the back of the image and allow the water to soak into the paper for a minute or two. I like to make a big puddle of water and get the image really wet.

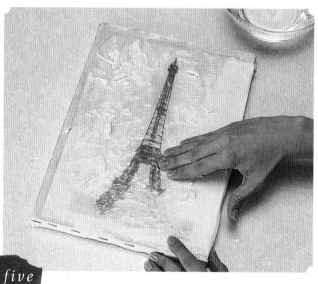

five

Rub Off the Excess Paper

Begin rubbing away the paper backing with your fingers. Use a lot of water! The more water you use, the easier your job will be. Keep rubbing until you have removed all the paper and only the transferred image is left. Let the image dry.

You might notice a white haze come back after you think you have completely rubbed off the paper. Don't worry, just rewet and rub off the remainder of the paper. It takes a little work and a few tries, so be patient.

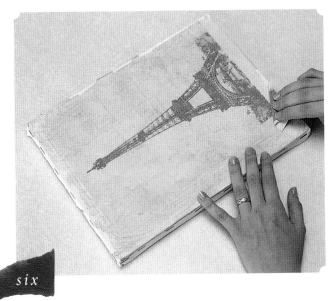

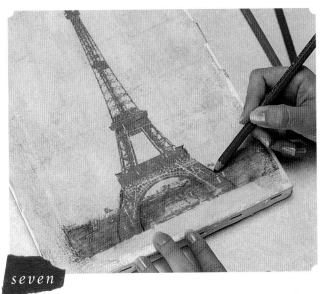

six

Soften the Edges With Sanding

Depending on the effect you want to create, you may want to sand the edges of your transfer to soften any areas that have hard lines. This can add a soft, pastel-like look to your image.

seven

Add Details With Colored Pencils

Add more detail and other finishing touches with colored pencils. You can also use colored pencils to correct any areas that didn't transfer completely.

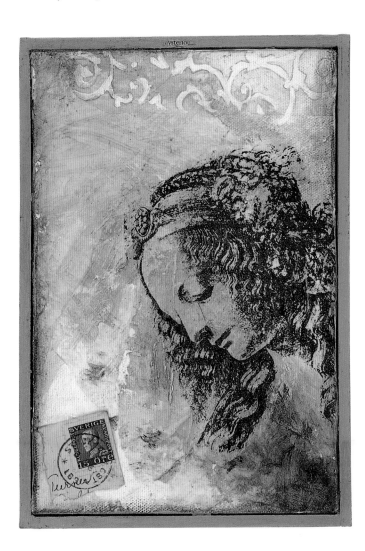

The Bride of Quietness

9½" x 6½" (24cm x 16.5cm)
I created this peeling paint background by using white peeling paint layered with glazes on top of grays and Raw Sienna. After it was dry, I transferred the Leonardo da Vinci drawing on top of the background using the caulking transfer method.

contact paper transfers

A SIMPLE WAY OF TRANS-FERRING BLACK-AND-WHITE PHOTOCOPIES AND COLOR LASER COPIES IS WITH CONTACT PAPER OR CLEAR PACKING TAPE. THIS IS EASY TO DO AND IT'S QUICK, TOO.

 you will need

clear contact paper or clear packing tape ★ scissors ★ black-and-white photocopy or color laser copy (ink-jet prints will not work) ★ bone folder ★ bowl of water ★ art surface (I used a playing card) ★ gel medium ★ paintbrush

I would like to share this fun technique with you in case you haven't discovered it already. You can create this transfer with adhesive laminate, packing tape or contact paper. Basically anything that is sticky on one side and clear on the other will work!

The best feature of this transfer technique is that you don't have to worry about your image being reversed like you do with the other transfer methods. With the contact paper transfer, your image will automatically be facing the correct way.

★ **adding color** If you have a black-and-white photocopy and you would like to add color to it, use colored pencils to add color to your copy before you transfer it. The colored pencil will transfer along with the rest of the image and create a nice effect!

Another way to add color is to use colored packing tape for your transfers instead of clear. Think of the interesting effects that can be made with blue, red or yellow packing tape.

one

Apply the Contact Paper to the Image

Measure the clear contact paper and cut it to the same size as your copied image. Peel the protective backing off the contact paper and press the sticky side of the contact paper to the copied image.

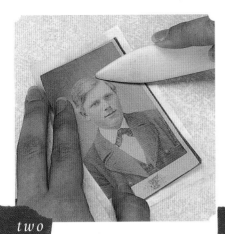

two

Burnish the Contact Paper

Burnish the surface with a bone folder or other burnishing tool. Give it a really good rub to make sure it is stuck together well.

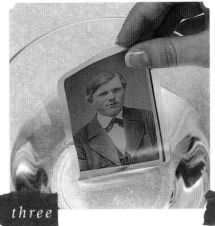

three

Soak the Image in Water

Soak the whole piece in a bowl of water or your sink for several minutes. The longer you soak it, the easier your next steps will be.

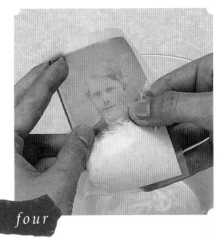

four

Rub Off the Wet Paper

Gently rub off the back of the paper with your fingertips. Your image will remain on the sticky surface and appear completely transparent!

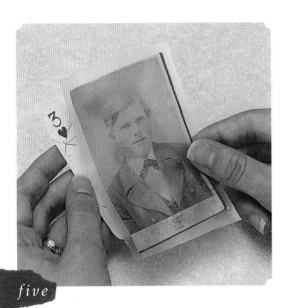

five

Glue Down the Transfer

Lay your transferred image on top of another surface to allow the background to show through. Here, I used a playing card that I decorated with a heat transfer of a diagram. Glue the image down with gel medium.

William 6½" × 5¾" (16.5cm × 14.5cm)

The transparency of contact paper transfers makes them especially effective for layering photocopies of old pictures over patterns and text. I especially like how the serious man contrasts with the whimsy of the beaded frame.

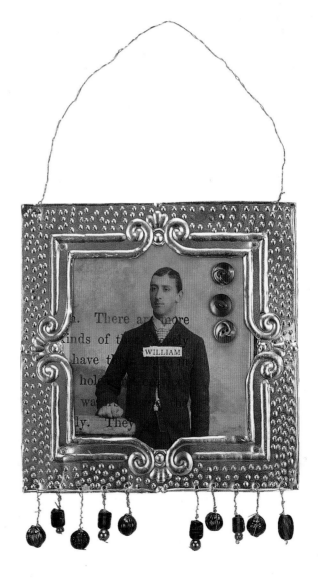

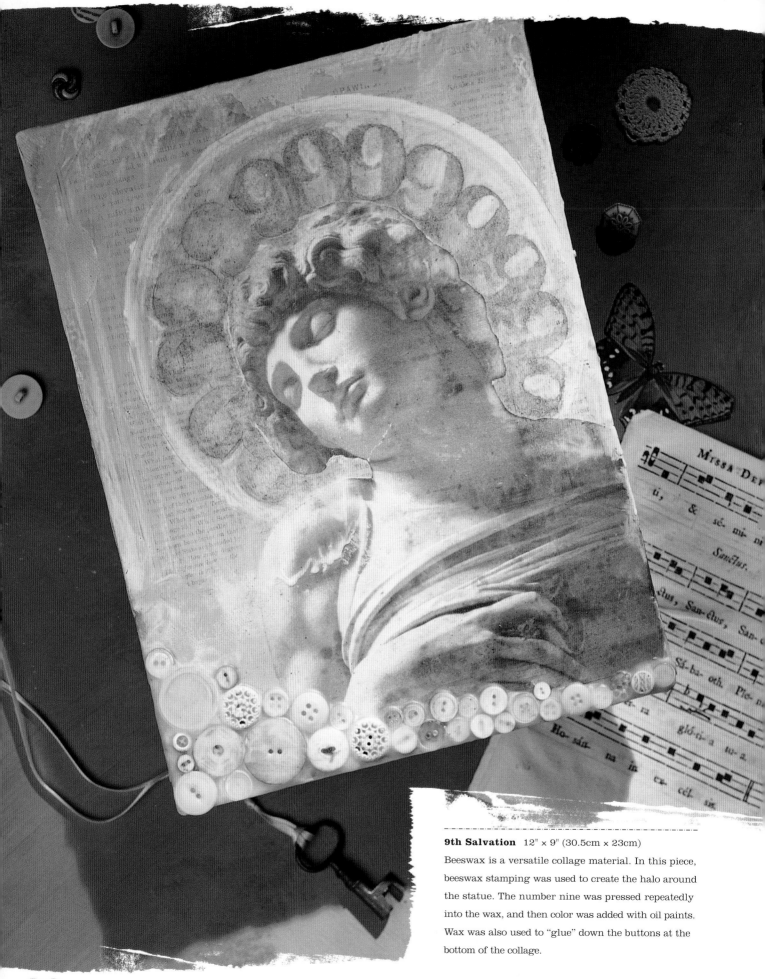

9th Salvation 12" × 9" (30.5cm × 23cm)

Beeswax is a versatile collage material. In this piece, beeswax stamping was used to create the halo around the statue. The number nine was pressed repeatedly into the wax, and then color was added with oil paints. Wax was also used to "glue" down the buttons at the bottom of the collage.

HAVING FUN *with beeswax*

Beeswax! Just the smell and the process of melting wax and using it in one's artwork seems so magical, almost as if you were making a potion. I have become addicted to incorporating beeswax into my artwork, and I am sure you will, too, once you try it.

My favorite thing about beeswax collage is that it gives you the ability to change your artwork at any time in the creation process. Even after days of letting your artwork sit around, if you decide you'd like to move a collage element to another place or remove it altogether, you can! It's perfect for those of us who are worried about using a precious collage element for fear of "misusing" it. This way, there is no need to worry. If you don't like where you put it the first time, you can move it!

I have experimented with using beeswax in mixed-media collages for many years. In this section, I will show you some of the favorite techniques I have developed over time. The first demonstration will teach you how to use beeswax as a glue and how to add color to beeswax with crayons. Then, I'll introduce the magic of wax transfers. Finally, you'll learn how to create textures in beeswax with stamps. Each of these techniques is simply amazing!

{TECHNIQUE} *wax collage*

you will need

beeswax (not paraffin or candle wax) ★ slow cooker or double boiler (see safety tips on page 45) ★ old paintbrush (dedicated to beeswax collage) ★ art canvas or other surface ★ various collage items ★ heat gun ★ quilting iron ★ crayons ★ paper towels

THIS LITTLE DEMONSTRATION WILL GET YOU ACQUAINTED WITH THE BASIC TECHNIQUES USED IN A BEESWAX COLLAGE. Collaging with warm wax may seem strange at first, but it can also be creatively liberating. After all, if you don't like where you put an element the first time—you can move it! So have fun changing around your composition until you get it just the way you want it.

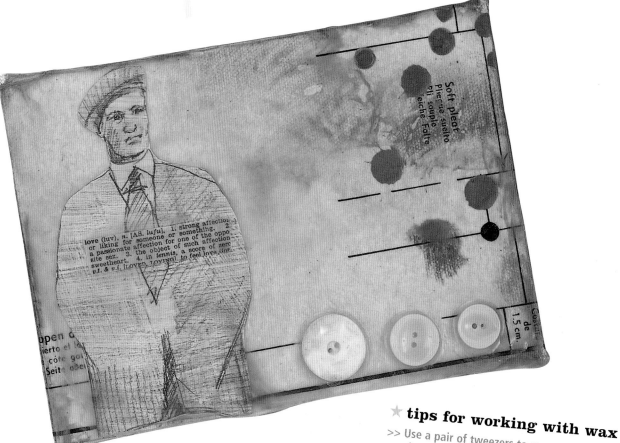

★ tips for working with wax

>> Use a pair of tweezers to move around collage elements that are covered in melted wax. This will keep your hands clean and prevent you from being harmed by the hot wax.

>> You can easily break up a large block of beeswax by freezing it first. Place the block of wax in the freezer for an hour, then put the wax in a plastic bag and break it apart with a hammer.

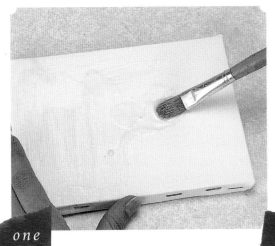

one

Coat the Surface With Wax

Cut off wax shavings and melt them in a small slow cooker set to low heat. (See the safety tips below.) Once the wax has melted, dip an old brush (one you don't mind ruining) into the wax and brush the wax over the surface you wish to collage.

two

Add a Background Paper

Begin by creating a background for your collage. Translucent tissue from a dress pattern works well. Press a large scrap of dress pattern paper into the wax. Don't worry if the wax has already hardened, this won't matter.

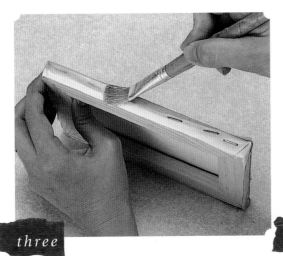

three

Brush Wax Over the Collage Piece

Add wax on top of the dress pattern paper and coat the edges of the canvas, too. You'll notice that the wax will coat the collage piece that you just added, and it will adhere the collage piece to the canvas just like glue.

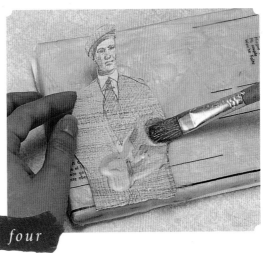

four

Add a Figure to the Collage

Choose a cutout of a person and place it on the background. Brush over the figure with more wax to glue it down.

★ safety tips for melting beeswax

You can melt wax in a couple of different ways. You can create a double boiler on your stove or use an old slow cooker. I prefer to use a small, inexpensive Slow Cooker that I bought just for melting wax. Keep your slow cooker at a low setting and you'll be ready to go. If you use one that you already have at home, just be aware that you will never be able to cook in it again! If you decide to melt your wax in a double boiler on the stove, be very careful. Wax has a very low flash point and can catch on fire. Please keep your wax under 200° (93°C). Using a slow cooker is much safer than using a double boiler, because you can control the temperature and keep it nice and low to avoid any hazards. If you like working with beeswax, a slow cooker is well worth the cost.

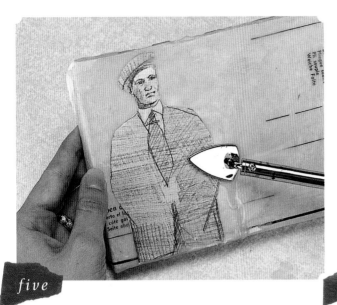

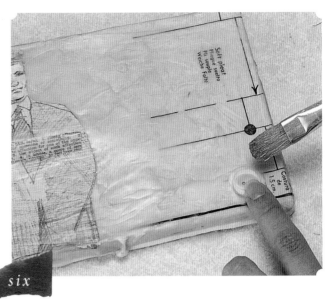

Smooth the Wax With a Quilting Iron

Iron over the surface with a quilting iron; this will smooth out all the bubbles and will help the wax to lay nice and flat. Add more words or images to the piece. I found an entry from a dictionary to paste onto this collage.

★ **going transparent** Some papers react differently to the wax and will turn transparent. You'll need to experiment with different types of papers to see how they will react to the wax. I personally enjoy the unexpected surprise when a paper I thought would remain opaque turns transparent! If you don't want your paper to turn transparent when you use it with beeswax, seal it first on both sides with gel medium, let it dry and then incorporate it into your artwork.

Attach Small Buttons With Wax

Next, you can add some texture. Use beeswax to attach beads, buttons, charms, lace or any other small objects you like. Drip wax onto your artwork and then press the objects directly into the melted wax. Here, I have added some old buttons. Add a few more drips of wax on top of the buttons to seal.

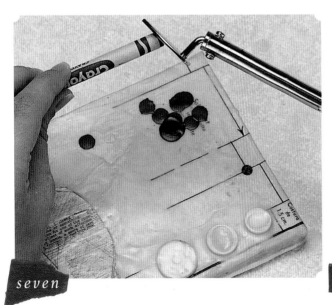

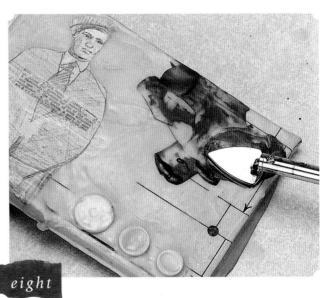

Drip Colored Wax on the Surface

To add some color, press the tip of a wax crayon directly against the quilting iron and allow the colored wax to drip onto the artwork.

Blend in the Color

Gently run the quilting iron over the crayon drippings to blend the color into the background. Experiment by using more than one color of wax.

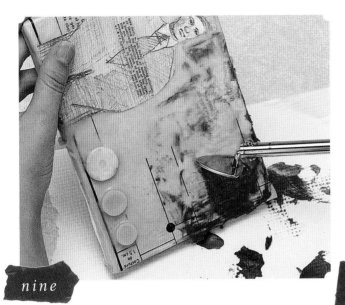

nine

Scrape Off Any Excess Color

If you think you have added too much color, you can scrape off the excess wax with the edge of your iron onto a paper towel.

★ irons and heat guns

>> The edge of an iron can be used to stipple lines of texture across the surface or to remove excess wax from a collage.

>> Use an iron to heat the underside of the artwork so that you can brush the wax around on your surface.

>> A heat gun set to high is a useful tool to liquefy wax or for blending dry or stiff brushwork.

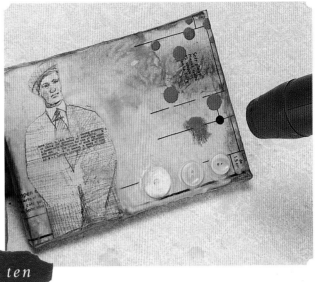

ten

Soften the Edges With a Heat Gun

For a softer effect, use your heat gun to smooth out the colors and to blend some of the color drippings.

As you can see, beeswax can be used in several different ways to create an interesting surface full of color and texture. Best of all, you can always reheat the wax and keep changing or adding to your collage until it is just right.

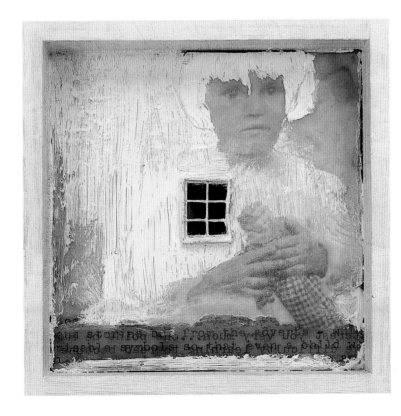

Everyday Memories
4½" x 4½" (11.5cm x 11.5cm)
This collage was created with beeswax. I cut a small hole in the canvas, added the window frame and glued that in using wax. When the collage was almost completed, I brushed white oil paint on top of the artwork around the image of the little girl. Notice how the words at the bottom of the piece are a little see-through and you can almost make out the back of the typed page? This is what happens sometimes when wax soaks into different papers; you see what's on the reverse side of the page.

wax transfers

W AX TRANSFERS ARE EASY TO DO AND ARE A FUN WAY TO GET PATTERNS OR OTHER DESIGNS INTO YOUR ARTWORK. Keep in mind that you might want to do the wax transfer as the last step in your wax collage. If you use the heat gun on your wax transfer, it will all melt away.

Many times I have heard that artists use nail polish remover (or acetone) to transfer their images to various surfaces. I never could get it to work right—until I tried the transfer on wax. When you use the nail polish remover method on a layer of beeswax, you get a clean and clear transfer. It's easy!

you will need

beeswax pellets ☆ slow cooker or double boiler (see the safety tips on page 45) ☆ old paintbrush ☆ art surface ☆ color laser copies or black-and-white photocopies ☆ paper towels ☆ nail polish remover with acetone

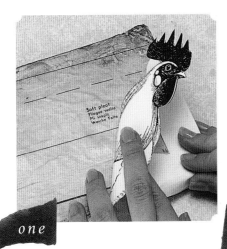

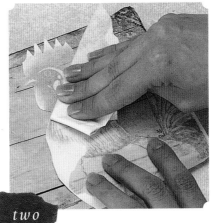

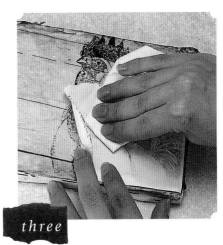

one

two

three

Brush Wax Onto the Collage Surface

Heat the wax pellets in a slow cooker or double boiler. (See the safety tips at the bottom of page 45.) Decide in which area of your artwork you would like to transfer your image. Prepare the area by giving it a quick brush with a little bit of melted wax. Choose a black-and-white photocopy of an image you like and place it facedown on the wax surface.

Dab the Back With Acetone

Wet a paper towel with nail polish remover and dab it on the back of the photocopy.

Check Your Progress

Gently pull up a corner of the photocopy and check to see if the image has transferred to the wax. If it has not fully transferred, then continue dabbing at the image with the nail polish remover. Your photocopy should easily transfer to the wax with one or two tries.

⭐ **transfer tip** Be careful not to heat the transfer image area with your heat gun or else your transfer will melt off. This can be used to your advantage, though. If you are not happy with the placement of your transfer, simply heat the area with your heat gun and you will be able to melt off the transfer and try again.

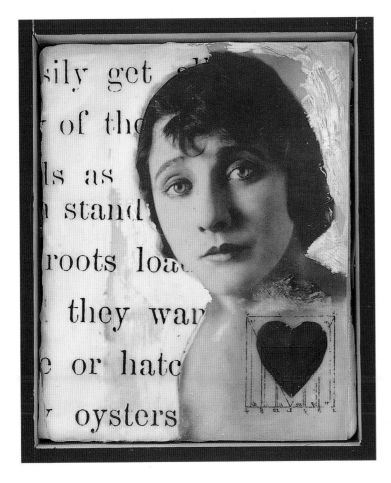

Caged Heart

5½" × 4½" (14cm × 11.5cm)

This collage is a good example of how a beeswax transfer can be used as a perfect last step in your collage. Everything in this collage was glued down with beeswax. Once all the pieces were in place, I transferred the square diagram over the woman's heart using nail polish remover. The effect created a little cage to complete the theme of this piece.

wax stamping

you will need

beeswax pellets ✶ slow cooker or double boiler (see the safety tips on page 45) ✶ collaged art surface ✶ old paintbrush ✶ heat gun ✶ deeply etched rubber stamps ✶ oil paints ✶ paper towels

ANOTHER WAY TO ADD TEXTURE AND INTEREST TO A BEESWAX COLLAGE IS TO STAMP INTO THE WAX WITH RUBBER STAMPS. I especially enjoy stamping letters and numbers into my artwork, and using wax is a quick way to do it.

The best types of stamps for this technique are deeply etched stamps with a simple design, like letters, numbers or patterns. Photo-type stamps or ones with intricate designs will not work as well.

one

Brush On a Puddle of Beeswax

Heat the wax pellets in a slow cooker or double boiler. (See the safety tips on page 45.) Use a brush to spread the molten wax onto your collage in a small puddle the size of your stamp. You want the surface of the wax puddle to be smooth and not lumpy. If it is lumpy, give it a blast with your heat gun to smooth out the top.

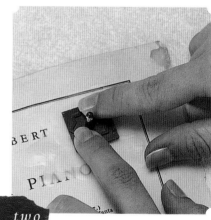

two

Press a Stamp Into the Soft Wax

Touch the wax with your finger to test it. The wax should be warm but not hot to the touch and should have a cloudy look to it. When you think your wax is ready, take your stamp and firmly press it into the wax. Be careful not to move your stamp when you press down; sometimes the wax can be slick and cause your stamp to move.

SALABERT

POUR PIANO

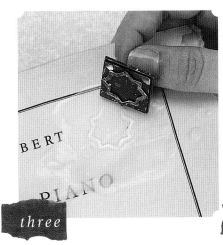

three

Remove the Stamp

Carefully lift off your stamp. You'll notice a faint outline or groove where the stamp left an impression in the wax. If you are not happy with the impression, simply blast away at the wax with your heat gun and start again. Nothing will be ruined!

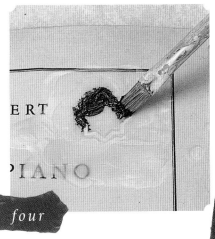

four

Rub Oil Paint Into the Grooves

After you have stamped into the wax, you might want to enhance your stamped image. Take a little bit of oil paint on a brush or a rag and gently rub it into the grooves that were created by your stamp.

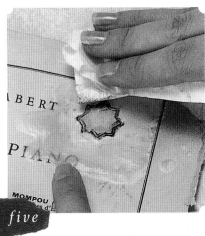

five

Wipe Off the Excess Paint

Take a clean rag or a paper towel and buff away the oil paint. You'll notice that the oil paint stays in the grooves of the image and brings out the detail of your stamped design!

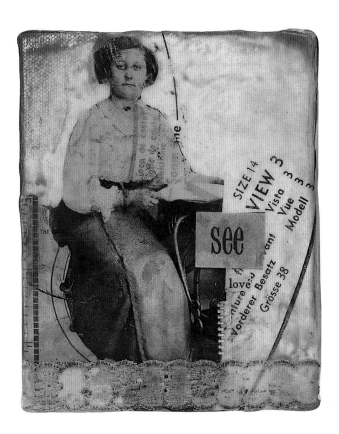

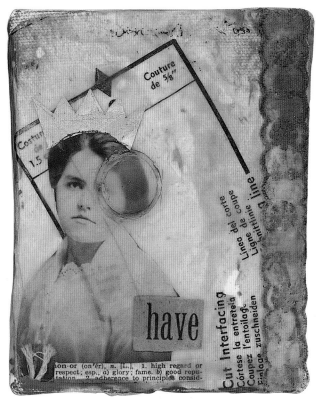

See, Have 5" × 4" (12.5cm × 10cm) each

These works were created completely with wax. I "glued" on all the elements, including the lace, with wax. When you use wax over fabric it can create some really interesting effects. Once the pieces were almost complete, I used crayon drippings to add color and wax stamping to add the big circle.

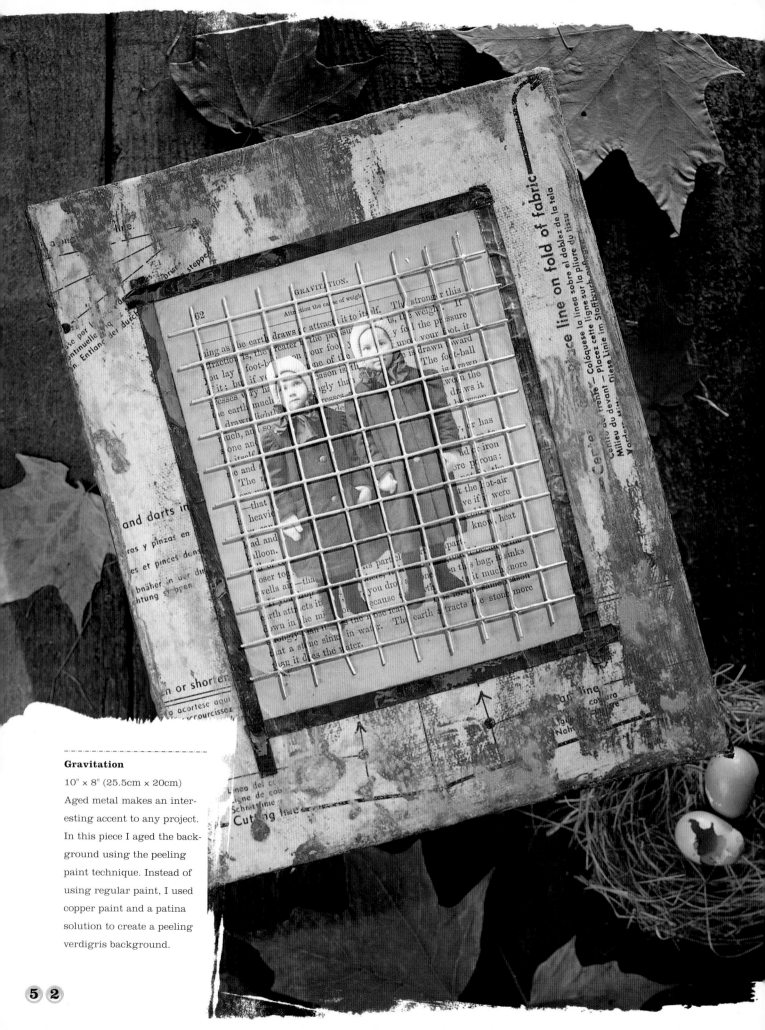

Gravitation

10" × 8" (25.5cm × 20cm)
Aged metal makes an interesting accent to any project. In this piece I aged the background using the peeling paint technique. Instead of using regular paint, I used copper paint and a patina solution to create a peeling verdigris background.

ANTIQUING *found objects*

Using aged objects in your artwork adds a feeling of history and authenticity to your piece. But sometimes finding old objects can be difficult, or we don't want to include expensive antiques in our artwork.

These days we all seem to want the objects that we use in our mixed-media artwork to be old or at least appear old if they are new.

There are some easy ways to create old-looking objects even if you just bought them yesterday from the dollar store. You can create real rust using vinegar and bleach, or create faux rust and aged patinas using products from your art supply store or create an aged look using ordinary acrylic paints.

Let's try these techniques and you'll see how easy it is to create historic-looking elements to add to your artwork.

antiquing *with acrylic paint*

A QUICK WAY TO AGE OBJECTS WHEN IN A RUSH IS TO COAT THEM WITH A WASH OF ACRYLIC PAINT. Typically I use a light coat of a Raw Umber acrylic on light-colored objects, and Titanium White on dark-colored objects. Or you might try the exact opposite to create a completely different look. When the paint is dry, you can sand off some of the paint to create a more realistic aged effect.

you will need

small objects you'd like to age ☆ acrylic paint: raw umber and titanium white ☆ paintbrush ☆ paper towels

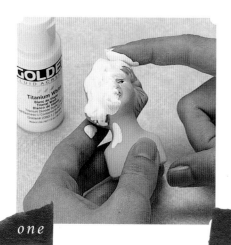

one

Apply a Coat of White Paint

Choose an object to age and coat it with Titanium White paint. Here, I have chosen a plastic doll's head.

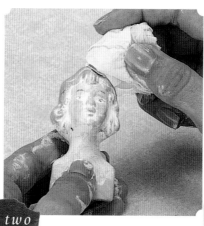

two

Wipe Off the Excess Paint

Rub off the excess paint with a paper towel. The remaining paint creates a nice bleached or weathered effect. For an even more aged effect, try scratching or sanding selected areas after the paint has dried.

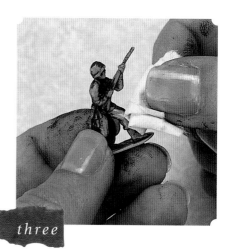

three

Weather Objects With Dark Paint

For a different weathered effect, coat plastic toys, such as this army figure, with Raw Umber acrylic paint. Rub off the excess paint. Your figure will look as if it has been buried in the mud for a few decades.

rusting metal
with vinegar and bleach

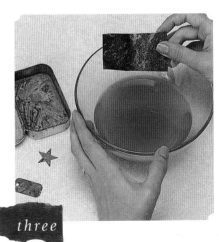

THE "AUTHENTIC" WAY TO RUST METAL IS TO CREATE ACTUAL RUST.

A simple way to do this is to soak metal objects in a solution of vinegar and bleach. Some items you may want to try rusting are nails, metal scraps, candy tins, metal dog tags, chicken wire and bottle caps. Given a choice, I have found that tin rusts the fastest and gives the most pleasing look with this technique.

 you will need

vinegar ★ bleach ★ bowl ★ assorted metal objects (tin works best) ★ steel wool (optional) ★ paper towels

★ safety precautions

PLEASE BE VERY CAREFUL WHEN USING THIS RUSTING METHOD! Do it outside with good ventilation, wear a mask, and don't breathe in the fumes. The fumes can be toxic.

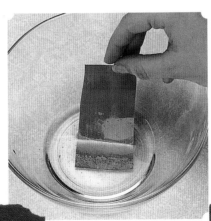

one

Prepare the Solution

Mix a solution of half bleach and half vinegar. Mix enough to completely cover the objects you wish to rust.

two

Soak the Metal in the Solution

Drop your metal into the solution. Some metal objects may require a light sanding with steel wool to get the protective coating off so they will rust properly. To accelerate the rusting, add an already-rusted item to the solution.

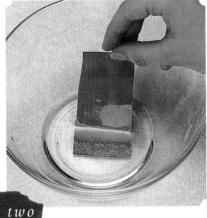

three

Air-Dry the Rusted Objects

Tin pieces should rust in a matter of minutes. If you are using metals other than tin, you might need to leave them in the solution anywhere from two days to a week. Once your objects are rusted, set them out to dry on paper towels.

using an *instant rust kit*

you will need

assorted objects (nonmetal objects are fine) ★ instant rust antiquing kit (one bottle each of instant iron paint and instant rust solution) ★ paintbrush

MY FAVORITE METAL-AGING PRODUCTS ARE BY MODERN OPTIONS.

Modern Options offers two-part kits to help you rust metal and age copper. The best part is that these products allow you to antique objects that aren't even metal. You can add rust or a patina to plastic, paper, glass and fabric—you name it. If you can paint it, you can age it!

This old, rusted window looks so convincing that you would never guess that it is made of plastic! Create the same effect on all sorts of nonmetallic surfaces by following the steps below.

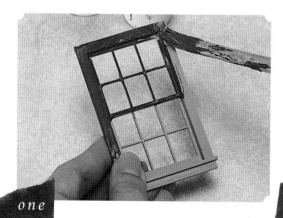

one

Basecoat the Object With Iron Paint

Choose an object to rust. Remember that you can use this technique on any surface you wish, not just metal. Brush on a basecoat of Instant Iron paint. This paint has iron particles floating in it, which will later rust. Set aside the object to dry, preferably overnight.

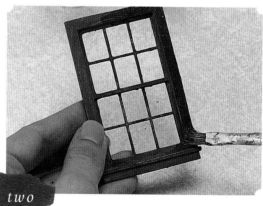

two

Apply a Top Coat of the Rusting Agent

Once the object is dry, paint on the Instant Rust chemicals. You will see your object begin to rust almost right away. For best results, leave it for a couple of hours and then apply a second coat.

creating a *verdigris patina*

you will need

objects to age (I used a glass box) ★ patina green antiquing kit (one bottle each of copper topper paint and patina green solution) ★ paintbrush

THIS IS AN EXAMPLE OF A REALLY INTERESTING WEATHERED COPPER EFFECT YOU CAN CREATE BY PAINTING OBJECTS WITH COPPER PAINT AND A PATINA SOLUTION. Use this two-step process on glass and you can make it look like the Roman glass from thousands of years ago.

★ more ways to antique surfaces

>> Instantly weather items made of copper and brass by coating them with the Patina Green antiquing solution.

>> Experiment with rusting ordinary household items such as paper, dolls' clothes and fabrics to create interesting results.

>> Use plain vinegar (with no bleach) on copper sheeting. It will lighten the copper and create some beautiful effects!

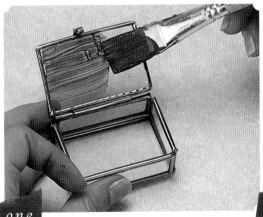

one

Basecoat the Object With Copper Paint

Choose an object to age. I am using a small glass box for this example. You could use glass bottles, optical lenses, watchmaker's tins, book covers or any other item. Paint the Instant Copper onto your surface. Coat the object well and let it dry overnight.

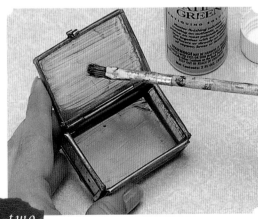

two

Brush on the Patina Green Solution

When the glass is completely dry, brush on the Patina Green solution. It may take a little time for the patina to set in. For best results, wait overnight, then add another coat of the patina solution. Notice how the copper has turned a beautiful antique green.

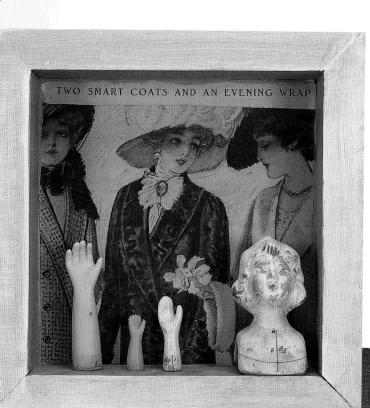

TWO SMART COATS AND AN EVENING WRAP

Two Smart Coats and an Evening Wrap

6¾" × 6¾" × 1½" (17cm × 17cm × 4cm)

I antiqued the doll's head in this artwork with acrylic paint. I rubbed the paint on and buffed it off for a nice aged look. I also used contact paper transfers to add the numbers and diagrams to the doll's arms and to the neck of the doll's head.

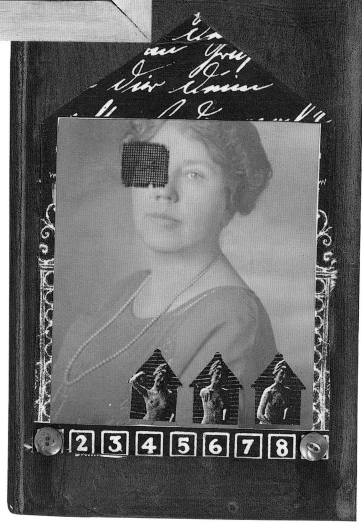

Rusted Journal

8½" × 5¾" × 1¼" (21.5cm × 14.5cm × 3cm)

This is a regular journal that I bought at the bookstore. I used the Instant Rust kit to turn it into a rusty journal cover. Notice how the cover now looks as if it's made of metal. Once it was rusted, I collaged on top of the cover and glued everything down using gel medium.

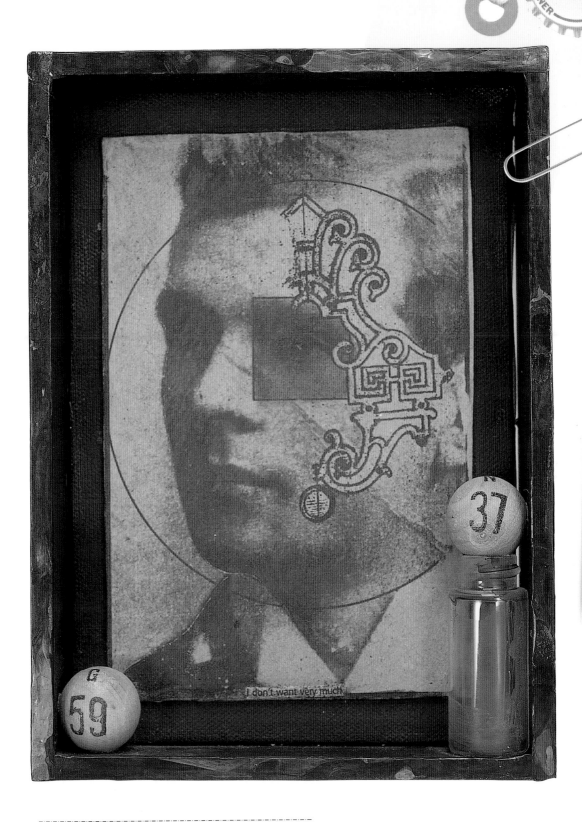

The Game of Life 7½" × 5½" × 1½" (19cm × 14cm × 4cm)

In this piece I used aged copper tape to edge the frame
of the artwork. It sets off the piece nicely and adds a little
bit of pizzazz to the frame.

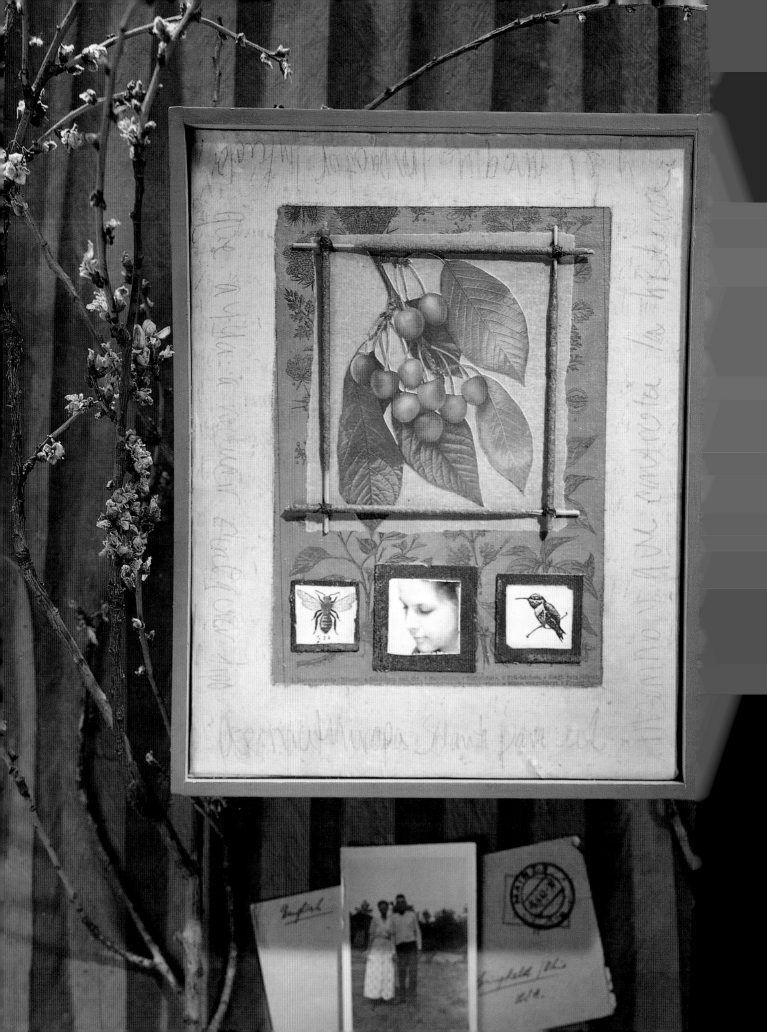

piecing it **all together**

This section of the book is where the real fun begins. Here, you can follow several demonstrations that show you some of the creative ways you can mix and match the techniques you have learned in the first part of the book. You will also find exercises about how to create a good composition. Along the way, you'll learn some tips on how to become a better collage artist—how to decide what works (or doesn't work) in your collage and why.

I hope this section will also give you a glimpse into the way I create my artwork. Most of the time, I start on a collage without any idea about where I want it to go. I simply work on the background and build up from there. I don't start with a vision and follow the directions. What fun would that be? Part of the fun is the discovery along the way, the happy accidents and seeing what comes next. I try to let the piece "tell" me where it wants to go next. So as I create each of the pieces that follow, I'll let you know what I'm thinking as I move from one step to the next. Then I'll ask you to look at your own work with the same curiosity.

These are simply exercises, and I want you to know that it's OK to take a different path with your own collage materials and it's OK to make "mistakes." Relax and have fun. Usually the pieces that I end up liking the best are the ones that gave me the most trouble along the way. It's all part of the process. Remember, you can always do the peeling paint background (my favorite "fixer upper" technique) or layer more paper on top. There is no way to ruin your piece! Now let's jump in!

> "Don't worry about your originality. You couldn't get rid of it even if you wanted to. It will stick with you and show up for better or worse in spite of all you or anyone else can do."
>
> **ROBERT HENRI**

facing page << **Esencia de la Aromaterapia** 10¼" x 8¼" (26.5cm x 21.5cm)
This collage is a creative mix of collaged papers, rusted metal and found objects. Arranging and rearranging different elements until they all fall into place is a magical experience. You could take the very same materials and techniques and come up with a completely different collage. Don't be afraid to experiment and make your own discoveries.

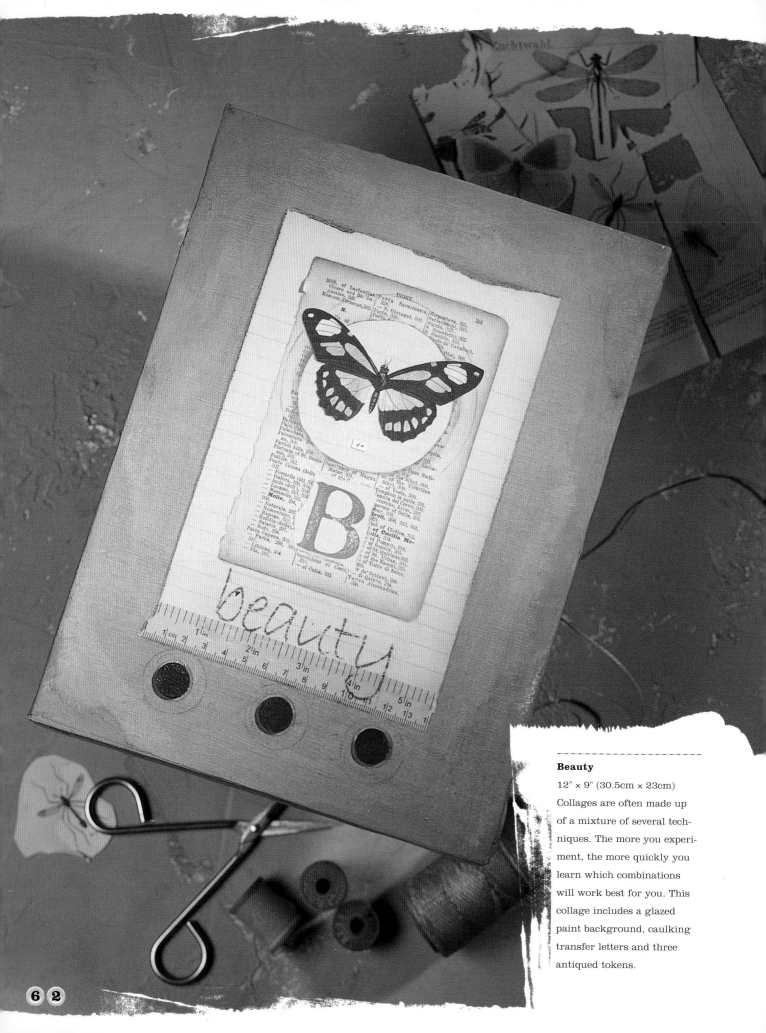

Beauty

12" × 9" (30.5cm × 23cm)

Collages are often made up of a mixture of several techniques. The more you experiment, the more quickly you learn which combinations will work best for you. This collage includes a glazed paint background, caulking transfer letters and three antiqued tokens.

experimenting IN COLLAGE

You're sitting with your collage materials at hand and want to make the most of them. Now what

So, you have learned a lot of interesting techniques and have hopefully created some luscious backgrounds to overcome the "blank canvas" syndrome.

do you do? How do you mix all the recipes learned so far to create something amazing? This chapter will give you some ideas of where to go next.

I want to impress upon you that all these techniques can be intermixed in ways other than the ones you see here. You could do the peeling paper technique and then do the petroleum jelly resist on top of that, or you could start with textured paint and later add peeling paper. You do not have to follow the exercises exactly as demonstrated. Follow your own instincts and choose a combination of techniques that most appeals to you. The possibilities are endless.

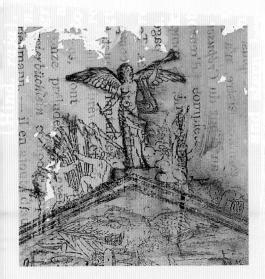

architectural *frieze*

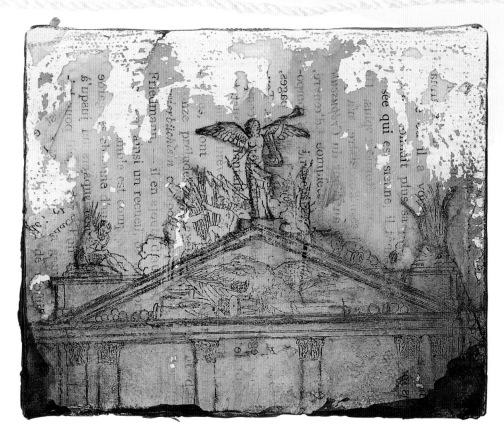

T HIS COLLAGE SEEMS TO OFFER A GLIMPSE INTO A FORGOTTEN ANCIENT

WORLD. You can create this same aura of mystery and nostalgia in your own collage work

simply by combining some of the techniques shown in the first part of the book.

This first collage exercise gives you a chance to practice the peeling paper technique, a heat transfer

and peeling paint. Notice how each new layer of paint or paper gives the piece more depth and interest.

 you will need

5" x 7" (12.5cm x 18cm) canvas or other small surface ☆ page of text from an old book ☆ paintbrush ☆ gel medium ☆ masking tape ☆ acrylic paint: yellow ochre, titan-buff and titanium white ☆ water ☆ black-and-white photocopy of architectural frieze (or other image) ☆ heat-transfer tool or small iron ☆ colored pencils (optional) ☆ petroleum jelly ☆ paper towels ☆ wax crayons ☆ quilting iron

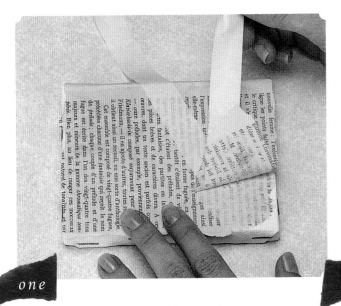

one

Create a Peeling Paper Background

Create an interesting background on your collage surface by using the peeling paper technique. Glue your page to the canvas with gel medium, then peel off sections of the paper with masking tape.

Here, I am using a page from an antique book, but you could also use a map or other printed piece. Right now, I have no idea where this piece is going, but I think the peeling paper would be a nice background to start with.

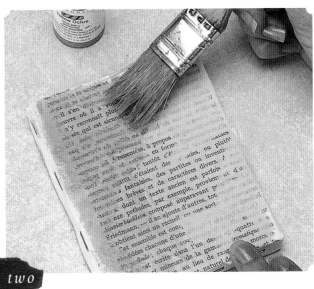

two

Add Some Color

To keep the background light but still add a little color, apply a wash of Yellow Ochre thinned with water on top of the torn paper.

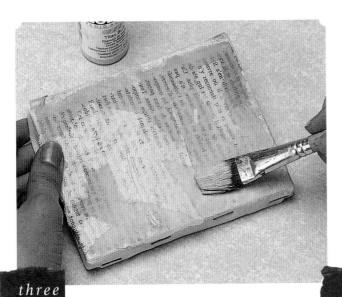

three

Tone Down the Background Pattern

Look at your background. Is it busy or full of strong patterns? In this piece, the text still seems a little too dominant for my eye; it would be difficult to see any images on top of this background. To tone down the surface, add a light wash of Titan-Buff paint. Once you think it looks ready to put an image on top, set it aside to dry.

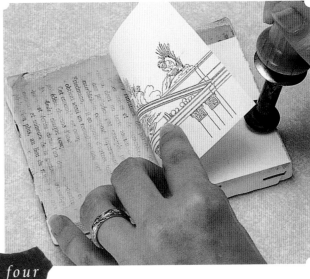

four

Transfer an Image Onto the Background

Heat transfers work well on a small surface like this one. Choose a photocopy of a subject you like and rub a heat tool over the back of it to transfer the image to the collage surface. Whatever image you choose, don't forget to lift a corner and check periodically to see that it is transferring well.

I really like the way this background looks, so I chose an image transfer method that allows the background to show through the image.

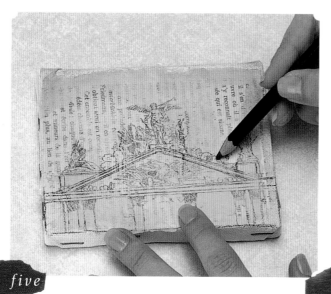

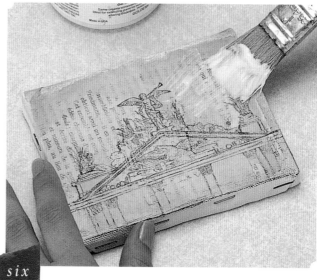

five

Touch Up the Image With Colored Pencils

If your tranfer didn't come through perfectly, don't worry. Simply touch up some of the details with colored pencil.

six

Coat the Surface With Gel Medium

The peeling paint technique will work well next, so brush on a layer of gel medium to protect the surface. If you have paper in your background and you want to do the peeling paint technique on top, make sure to protect it with a layer of gel medium. Otherwise the petroleum jelly will make the paper all greasy and you'll have a nasty mess.

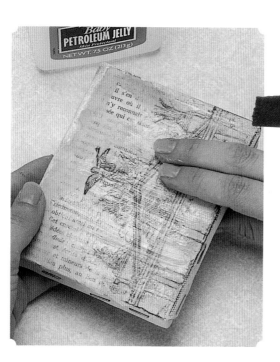

seven

Cover the Main Image With Petroleum Jelly

Now you are ready to apply the petroleum jelly that will make the paint peel. Focus on covering the main transfer image with a lot of the jelly, because you want to make sure that it will show through when the paint peels off. To create some variation, add a little bit of jelly here and there on the edges of the canvas.

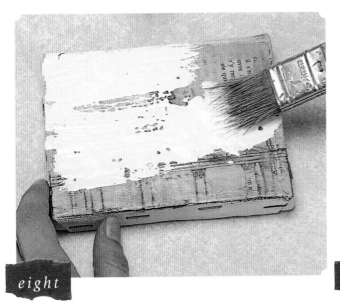

eight

Paint the Entire Surface With Acrylic Paint

Choose a color of acrylic paint that you think will look best surrounding your image and paint over the entire canvas, petroleum jelly and all.

I think white will be a nice color here; it will not draw too much attention to the peeled paint but will allow it to work in with the rest of the piece.

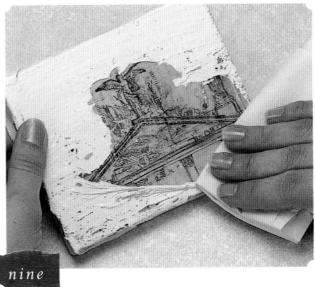

nine

Wipe Off the Loose Paint

After the paint is dry, rub off the paint with a paper towel and scratch off a little extra in areas where you want less paint to stick. I use my fingernails for this, but you can use sandpaper, too.

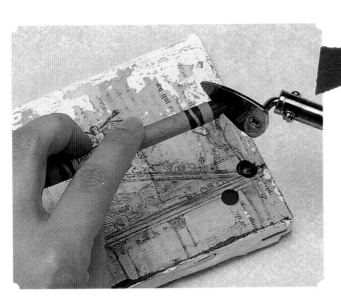

ten

Drip Wax to Add More Color

Look at your collage again. Do the colors you chose work well together? I think that this piece could still use a little extra color; it looks too monochromatic (all one color) to me. To add a little color, drip crayon wax around the edges with a small quilting iron.

Marie

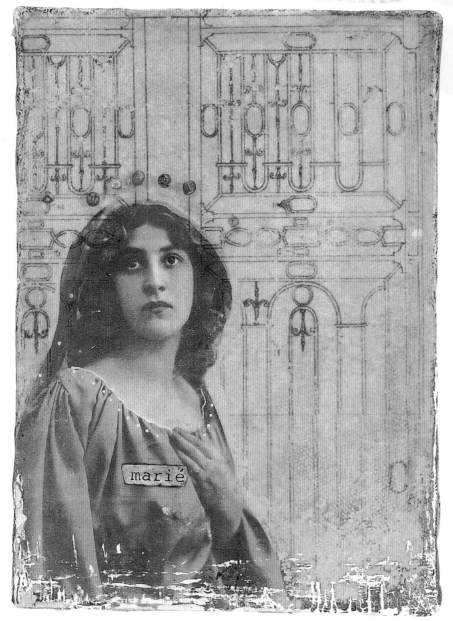

THE LADY IN THIS COLLAGE MADE ME THINK OF A SAINT. By coincidence, many of the items I had on hand worked well with that theme, so I added them in as I created the collage. Still, it's important to note that she could have turned out completely different if I had added a hat, or a husband, or a funny phrase beside her. So jump into this exercise with whatever images or embellishments you find and come up with a character or story of your own. Your collage doesn't have to look like mine. The idea is to have fun learning how different materials and techniques interact.

you will need

5" x 7" (12.5cm x 18cm) canvas or other surface ✯ dress pattern tissue or other tissue ✯ gel medium ✯ paintbrush ✯ color laser copies of people and patterns ✯ caulking compound ✯ bowl of water ✯ acrylic paint: titanium white and burnt sienna ✯ plastic spatula or paint scraper ✯ beads or other embellishments

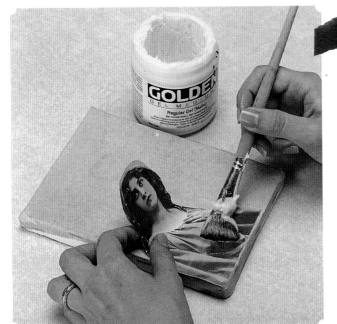

Paste Down a Figure

Create a subtle background by gluing a layer of tissue paper to your collage surface with gel medium. I used a section of dress pattern tissue. It is my favorite background material, because it has a soft color tint to it and creates a uniform background instantly.

Next, use gel medium to paste an image of a person on the background. I am using a color laser copy of a woman. I place her in the corner so that she appears to be facing into the artwork. This looks like a good start to me.

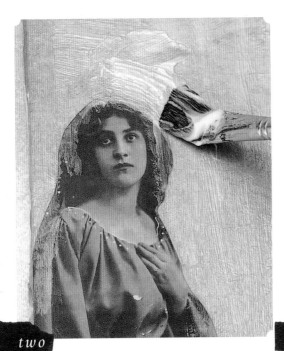

two

Brush Caulking Around the Figure

This woman looks a little lonely. She's floating in the corner of the canvas with nothing to look at. One solution is to transfer some sort of image behind her with the caulking transfer technique. Unfortunately, I already glued her down, but brushing the caulking compound around her head and shoulders, not over her face, easily solves this. This way, the background pattern to be transferred will look like it goes behind her head.

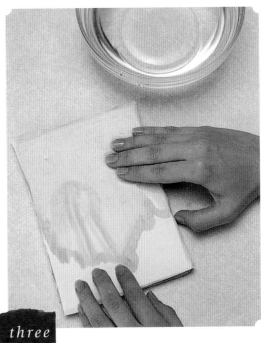

three

Transfer a Pattern Onto the Collage

For your transfer, choose a photocopy or color laser copy of an image or pattern that would look good surrounding your figure. I placed an image of an iron gate facedown into the wet caulking. Allow the image to dry, then wet the back of the paper to reveal the transfer.

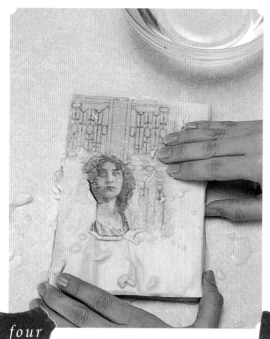

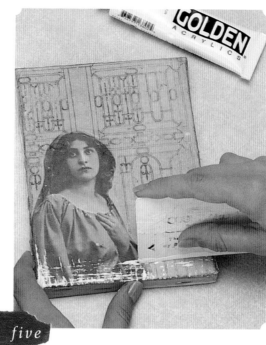

four

Rub Off the Paper Backing

Reveal the transfer by rubbing the wet paper backing off of the collage with your fingers. See how the gate appears to be behind the woman? Make sure to use lots of water and keep rubbing until you have removed all the paper.

five

Add Texture With Paint

If your piece seems a little flat, try adding texture with paint. You could use a paint scraper, a palette knife or an old hotel key card, as I have done here. The white paint at the bottom edge is just what it needed.

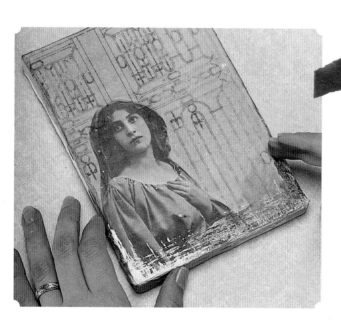

six

Color the Edges With Paint

The pale background of this collage looks like it needs a border around it to help frame the collage and add a bit more depth and color to it. Dab your fingers into a bit of acrylic paint and rub it along the edges of your piece. Choose a color deeper than your background. Here, I use a bit of Burnt Sienna.

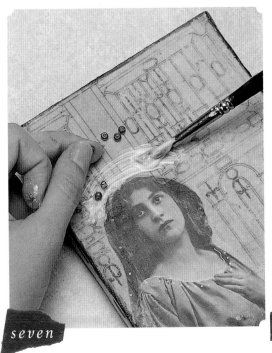

seven

Attach Some Embellishments

What small items can you add that would enhance your collage? Pick out things that relate to the main image you have chosen and glue them down with gel medium.

I would like to draw some more attention to the woman figure, so I add a halo of blue beads around her head.

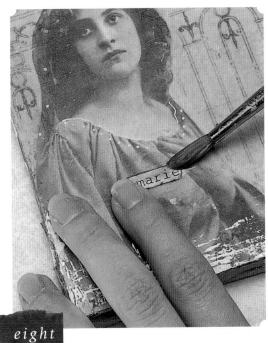

eight

Add the Finishing Touches

This collage still needs something extra, just a little something to finish the piece. One solution that might work here is to add a word or phrase to the collage. Look through old books and magazines and find a word that completes your collage and glue it down with gel medium.

I found the name **Marie** in one of my antique books. This name seems perfect; it alludes to a variety of stories for this woman and adds meaning to the piece. You might choose a word or phrase that conveys a completely different meaning—one that is ironic, whimsical or nostalgic.

{Practice} IN A *sketchbook*

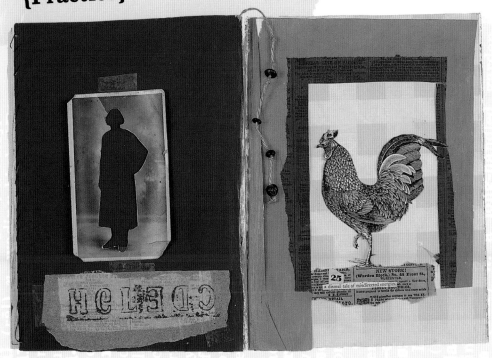

Just because these exercises are demonstrated on canvas doesn't mean that you can't explore other surfaces, as well. Try a few collage experiments in a large blank sketchbook instead. Glaze several pages with different-colored paints so that you have a series of colorful backgrounds ready at a moment's notice. When inspiration strikes, paste whatever catches your fancy into your sketchbook. It can be a great way to capture ideas before they disappear.

the making of a *Man*

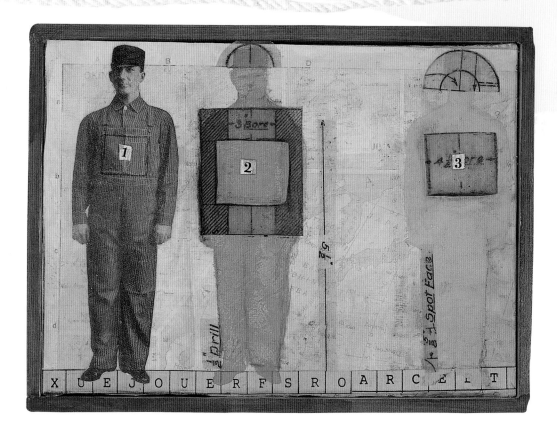

THIS COLLAGE ENDED UP BEING ALL ABOUT REPEATING PATTERNS. If you start a collage and don't know where to go with it next, you can use repeating shapes and patterns to create a wonderful collage. In this exercise, you'll learn how to create repeat patterns with stencils and contact paper transfers. Finally, we dressed up this collage in a quick and easy handmade frame that you can use on any of your collages. They can really make your artwork stand out!

 you will need

5" x 7" (12.5cm x 18cm) canvas ★ piece of an old map ★ gel medium ★ acrylic paint: yellow ochre, titanium white, cobalt teal and pyrrole orange ★ paintbrush ★ bowl of water ★ color laser copies of people ★ craft knife and cutting mat ★ scissors ★ collage ephemera (words or numbers) ★ cotton swab ★ colored pencils ★ black-and-white photocopies of patterns ★ contact paper ★ bone folder

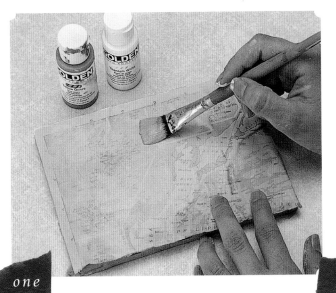

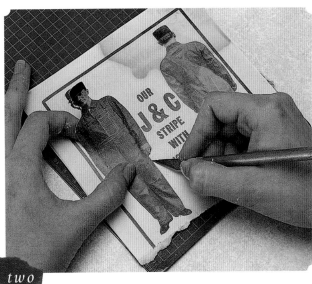

one

Create a Background

Prepare a canvas by gluing down a page of a map with gel medium. Mix a wash of Yellow Ochre and Titanium White acrylic paint thinned with water and brush it over the map to tone it down. This map seemed a little bright to me, and I want to push it into the background so I can layer more collage elements on top.

two

Cut Out the Main Image

This is a nice start. Now add a focal point to this piece. Find an image with an interesting profile among your collage materials and cut it out of the paper background using a sharp craft knife. I found a full shot of a man that fits my canvas well. Sometimes the scrap left behind after you cut out your image has an interesting outline. Save this silhouette; it will make a wonderful stencil.

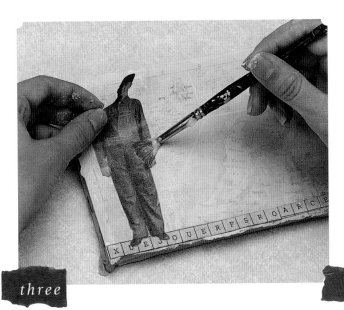

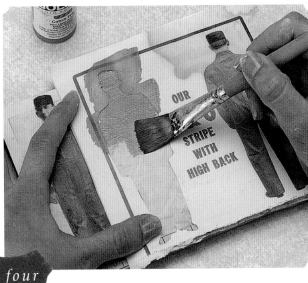

three

Paste the Figure on the Surface

Use gel medium to glue down your figure. To make room for some more images in this collage, place your subject off to one side.

Does your figure appear to be floating on the canvas like mine did at first? Perhaps it needs something under it to "ground" it. Look for a strip of collage material to glue beneath your subject. Underneath my man, I added a little row of letters that I cut out from a word finder puzzle.

four

Stencil a Second Figure

If your figure looks a little lonely standing in the corner of the canvas, add another element or two. Repeating images are good for creating rhythm in a composition, but I have run out of copies of this man. One solution is to use the cutout you saved earlier as a stencil to create a second image beside the pasted one. I am brushing over my stencil opening with Cobalt Teal paint.

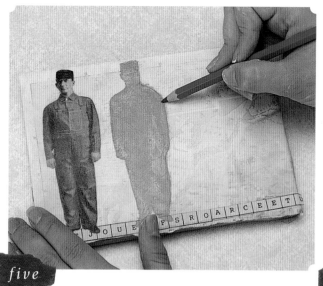

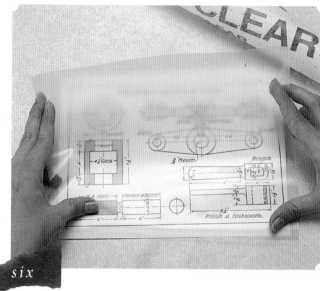

Clean Up the Edges

If the edges of your image have bled or smeared beyond the outline of the stencil, clean up the excess paint with a cotton swab. After the paint is dry, you can also touch up the image with colored pencils.

Now that my first painted man is done, I will add a second stenciled man, this time in a lighter shade of blue. Using the same shape but a different color adds a bit of variety.

Apply Contact Paper to a Pattern

Look at your collage. Do you like the effect created with the repeat images? Do you need to add something more? The stenciled figures here seem too plain. I would like to add some detail to my stenciled men.

One way to add details without covering over too much of the subject is to transfer a design onto clear contact paper. Find a pattern that would work well with your own collage. I found a page of old diagrams and I love the look of them. Begin making the transfer by applying the sticky side of the contact paper to the photocopied pattern.

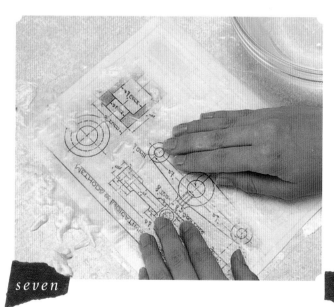

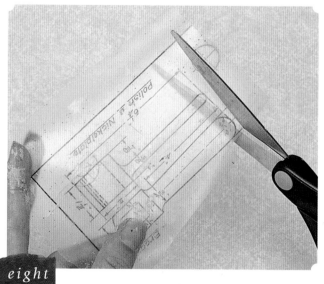

Finish the Contact Paper Transfer

With a bone folder, burnish the surface of the contact paper well to make sure that the image is completely adhered to the contact paper. Soak the whole sheet in water and rub off the back of the paper using your fingers to complete the transfer. Your finished sheet should be transparent, with only the design left.

Cut Out Your Favorite Elements

You can cover your entire collage surface with the contact paper transfer, but I prefer to cut out only the elements I like the most. Look at your collage and think about which areas need embellishment. Then cut out elements from your contact paper transfer that might work well in each of those spaces.

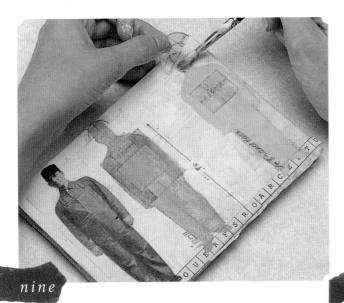

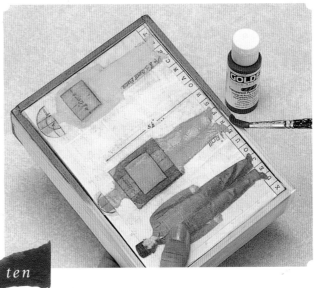

nine

Paste the Transfers Onto the Collage

Paste the contact paper transfers on top of the stenciled figures and around various areas of the canvas where they look best to you. Glue all these down with gel medium just as if you were gluing down a regular piece of paper.

ten

Paint a Complementary Colored Border

Now look at the overall colors used in your collage. Are they too similar? Does the collage need a contrasting border to frame it? If you wish, create a wooden frame for your piece by following the steps on page 16. Then paint the frame a color that will give your collage some punch.

I am adding a border in Pyrrole Orange acrylic paint. Since orange is the complement of blue, it contrasts the blues and turquoises in the artwork nicely.

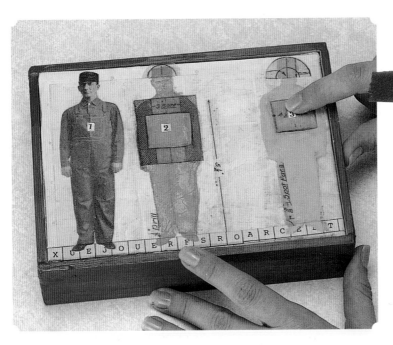

eleven

Add the Finishing Touches

Does your collage look finished? Paint or paste on any final embellishments if your work is not yet complete.

I still feel that these men need a little something extra. They look to me like they are on some sort of assembly line and that triggers an idea to accentuate that. I find some tiny numbers, and I add them to the men to finish the piece.

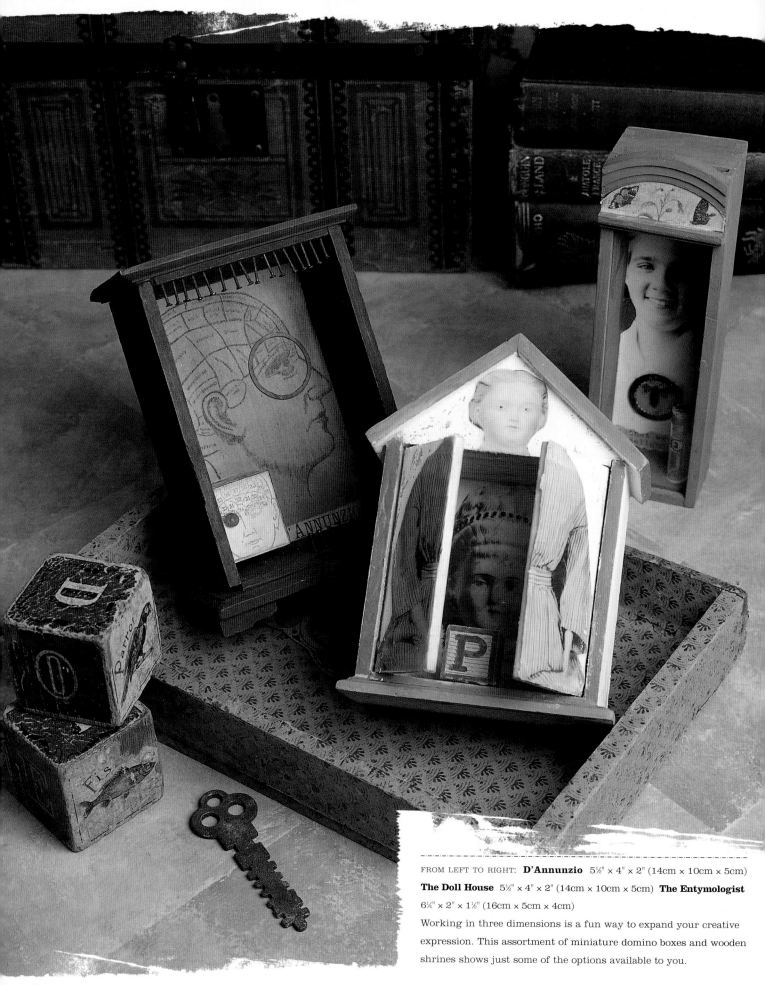

FROM LEFT TO RIGHT: **D'Annunzio** 5½" × 4" × 2" (14cm × 10cm × 5cm) **The Doll House** 5½" × 4" × 2" (14cm × 10cm × 5cm) **The Entymologist** 6¼" × 2" × 1½" (16cm × 5cm × 4cm)

Working in three dimensions is a fun way to expand your creative expression. This assortment of miniature domino boxes and wooden shrines shows just some of the options available to you.

CREATING miniature assemblages

Basically, assemblage is really just collage, but you use three-dimensional objects (sometimes combined with two-dimensional elements) to create your art piece. By working with three-dimensional objects, you can expand your

American Heritage Dictionary defines assemblage as "A sculptural composition consisting of an arrangement of miscellaneous objects or found materials."

resources for your art making even further.

Just about any object can become an assemblage item: doll's heads, glass bottles, rocks and stones, household objects, shells—

you name it! Likewise, you can create an assemblage in just about anything: domino boxes, mint tins, cigar boxes, watchmaker's tins and so on.

To give you an idea of the creative possibilities that assemblage offers, I'll demonstrate four different assemblage projects in three different containers, ranging from a tiny glass-topped watchmaker's tin to a shadow box you can build yourself. Remember, it is perfectly OK to improvise and modify each of these exercises to work with the materials you have on hand.

love

giving tin

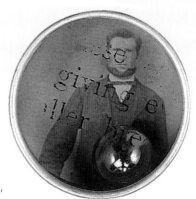

A SSEMBLAGE MAGNETS MADE FROM WATCHMAKER'S TINS ARE FAST AND FUN LITTLE PROJECTS, AND THEY MAKE GREAT GIFTS. These tins are a great place to combine color copies of your favorite photos with some tiny found objects. Small keys, game pieces, marbles and shells are just a few of the items you might add to your magnets.

In this demonstration, I use a heat-transfer tool to add words to the glass of the watchmaker's tin. When the words are transferred to the glass it creates a lovely three-dimensional effect; you get the shadow of the words cast onto your image below. Yum!

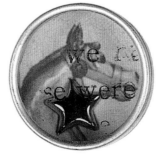

 you will need

watchmaker's tins ★ black-and-white photocopy of text ★ scissors ★ heat-transfer tool ★ assorted collage images ★ gel medium ★ paintbrush ★ assorted small assemblage items or found objects ★ small, round magnets

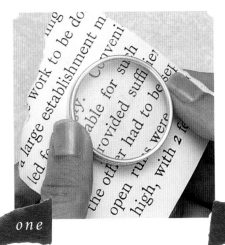

one

Select Words for a Transfer

We'll begin this project by using the heat-transfer method to place words on the glass lid. Choose which words you'd like to transfer by holding the lid of the watchmaker's tin up to a black-and-white photocopy of text.

Notice that the text does not need to be reversed on a photocopier first to turn out right because we are transferring it onto the back of the glass.

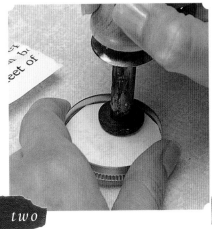

two

Heat the Back of the Text

Next, cut out the chosen section of words from the photocopy and place it facedown in the lid. Heat the back of the paper with the heat-transfer tool to transfer the text. Make sure to lift a corner and check often to see how your transfer is coming along.

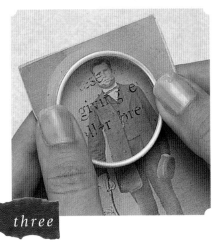

three

Choose a Matching Image

Hold the glass lid with the transferred words on it up to a color copy of an antique photo or other image. Look for the best position to frame the subject with the words. I chose this placement so that the words do not obscure the man's face. Trace around the lid.

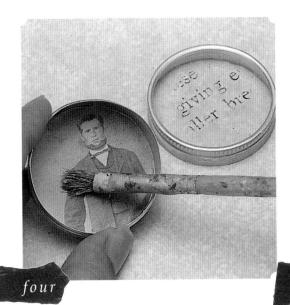

four

Glue the Image in the Tin

Cut out the color copy and glue it to the bottom of the tin with gel medium. Add a glass marble, beads or other small objects for a three-dimensional effect and close the lid on the tin.

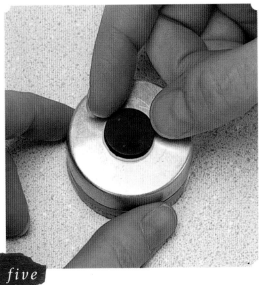

five

Add a Magnet

To finish your miniature assemblage, glue a small magnet to the bottom of the tin with gel medium.

the three of hearts

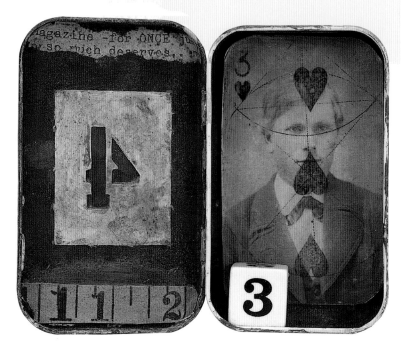

MINT OR CANDY TINS MAKE WONDERFUL MINIATURE SHADOW BOXES FOR YOUR COLLAGE AND ASSEMBLAGE CREATIONS. I like to rust mine first. Simply use paint thinner to remove the paint and then follow the rusting techniques on pages 55–56. You can use either the vinegar and bleach method or you can use a commercial rust kit. Either way, you'll get a nice rusty tin in no time.

★ **listen to your intuition** You don't have to plan out your assemblage in advance. Have some fun. Let each element of your assemblage influence what the next one will be. You might be happily surprised by the results.

you will need

contact paper transfer image (created on pages 40–41) ★ mint tin ★ assorted collage papers ★ assorted assemblage items ★ gel medium ★ paintbrush

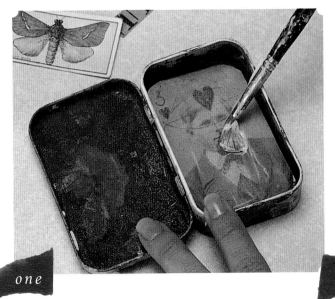

Make an Image Transfer

For this assemblage, start with the contact paper transfer that you created on pages 40–41. If you haven't made one already, make an image transfer onto a playing card. A playing card creates a nice image transfer background, and it fits perfectly into a 2¼" x 3½" (5.5cm x 9cm) mint tin. Glue the card in the bottom of a rusted mint tin using acrylic gel medium.

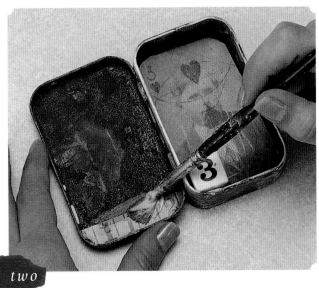

Find Related Elements

Sift through the collage elements and found objects that you have close at hand. Select the ones you think relate to your image transfer. Did you use a red playing card? You might try adding another heart shape, or an object with the color red.

I enjoy the number element in this piece. I discover a bit of vintage measuring tape that has the numbers **1** and **2** on it. With luck, I also find a game die with the number **3** on it! I add these elements into the tin so that they will read in numerical order: 1, 2, 3.

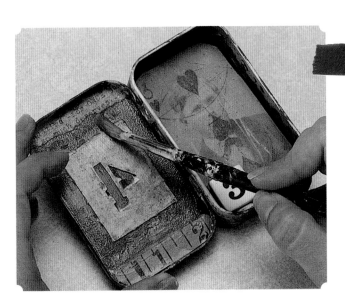

Fill in Any Gaps

Fill in any remaining gaps in your composition. You might try flipping each piece over or turning it upside down and see what happens. Sometimes, it's the unexpected arrangement that looks best.

I chose to glue a stencil of the number **4** into the lid. Notice that I put it backwards. When I placed the stencil in facing the right way, I noticed that it was leading my eye out of the piece, so I turned it backwards and it looked better that way. It also adds a nice quirky quality to the assemblage.

with great pride

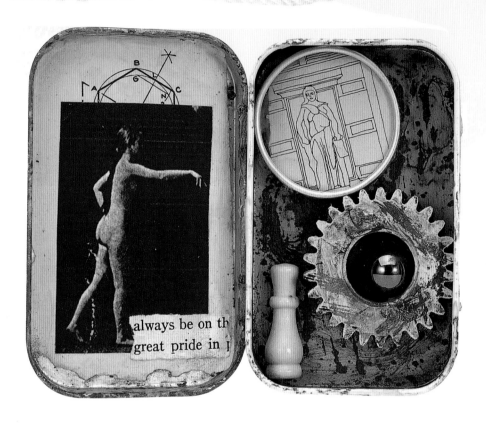

T HIS VARIATION ON THE PREVIOUS PROJECT SHOWS YOU HOW DIFFERENT

MATERIALS CAN TAKE YOU INTO VERY DIFFERENT CREATIVE DIRECTIONS.

The previous assemblage centered on repeating numbers. In this one, I play with geometric shapes.

★ help for the indecisive

If you are undecided about whether to use a particular grouping of elements in your assemblage, simply place the items in your composition without gluing them down. Add, remove or rearrange each piece until you find the arrangement that you like best.

 you will need

mint or candy tins ★ assorted collage papers ★ assorted assemblage items ★ gel medium ★ brushes ★ acrylic paint: titan-buff ★ paper towel

one

Choose a Collage Piece

Start by rusting a candy tin using one of the techniques on pages 55–56. Next, gather an assortment of interesting collage items. Just like me, you may not be sure how you want this piece to go. Let your various collage elements guide you.

A background piece to place in the lid of the candy tin is a good place to start. In my case, I am drawn to an antique piece of paper with various diagrams on it.

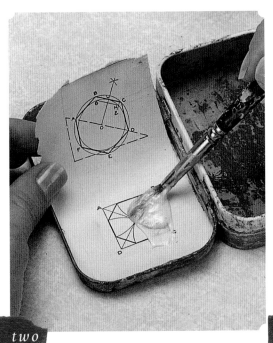

two

Paste in the Element

Tear out the image to fit the inside of the tin's lid and glue it down with gel medium. Since the lid is shallow, you might want to place mostly two-dimensional images inside it. Later, in the main part of the tin, you can add found objects.

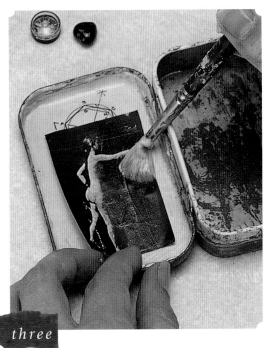

three

Choose the Next Element

Look for a second item to add to your tin. Allow this next element to play off the first and so forth until the composition tells you where to go next. I found a photocopy of a woman, and I liked the way the diagram came up over her head creating an arch when I placed her over the diagram paper. Go ahead and glue this next element down with acrylic gel medium.

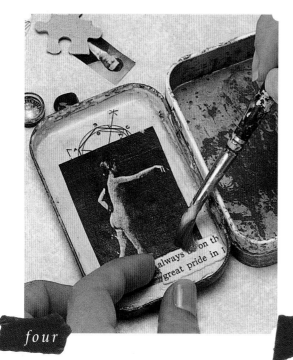

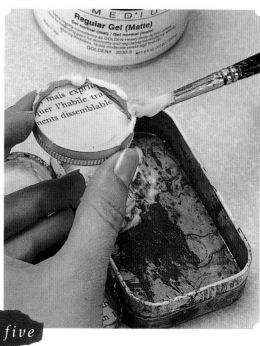

Add Some Words

See if there are any words or symbols that would work in your piece and glue them in using gel medium. I found a fragment of a page from a book with the words **great pride** on it. I like the way the phrase adds a little story to this piece.

Notice that I am overlapping the corner of the woman with the words. I like how this placement helps to break up the previous element. I feel like it was too much of a rectangle, and now with the words added on top, the piece feels more organic.

Add a Found Object

Try to make the second side of the tin relate to the first, like two parts of the same story. Look for objects that might go well with the elements you have already pasted into the tin and choose one to glue down.

I would like to continue using geometric elements. I found a lid of a watchmaker's tin, placed an architectural image in it and glued it down. I like how this round element echoes the arch above the woman's head.

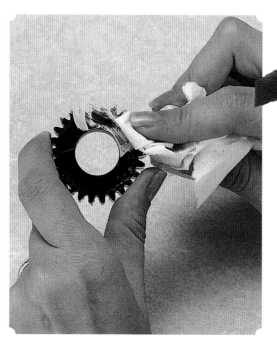

Continue Adding Objects

Look for more items to add to your piece. You might look for objects that have similar shapes or colors as the rest of your composition. If it captures your interest, try it out.

I found a round gear, and I think it will work nicely against the round watchmaker's tin lid. But it's too dark. So, I paint the gear with Titan-Buff paint and rub some of it off. This ages and lightens the gear a little, and now it will stand out.

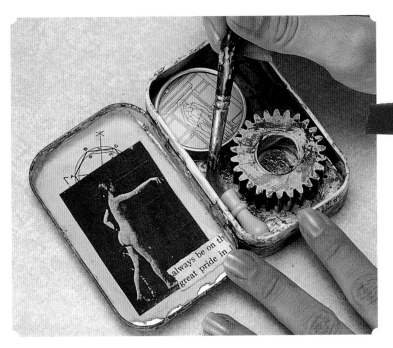

seven

Add the Final Touches

Add or modify the objects in your tiny assemblage until you are satisfied with the composition. Here, I have glued the gear into the tin and added a small chess piece to complete this assemblage. As you glue your objects down, clean up any excess gel medium with your brush.

★ **work with what you have** If you find an item that's not quite right for your assemblage, think of ways you can modify it to make it work. Rust it or antique it. Cut part of it off or cover it over with another material. Don't be afraid to experiment!

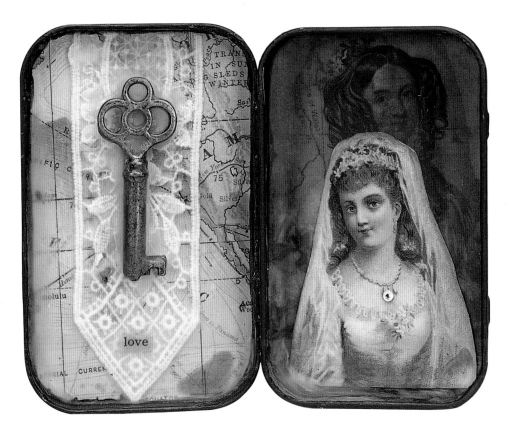

Love Is the Key

3¾" × 4¾" (9.5cm × 12cm)

This candy tin assemblage looks very different from the ones demonstrated so far. Instead of rusting the tin, I painted it brown. I used beeswax to glue all the pieces into place instead of gel medium. I decorated the outside of this tin with a vintage photograph of a couple and glued a ribbon to the back of the tin to tie it together with a bow.

shadow *box princess*

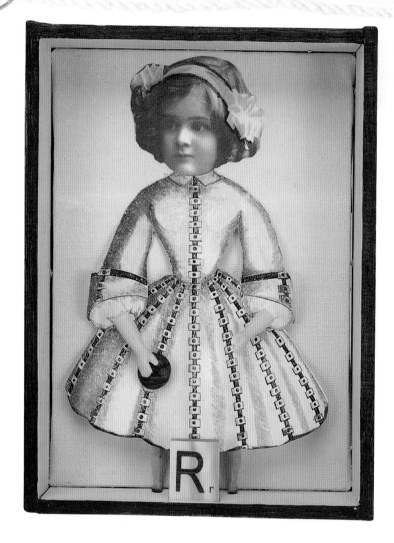

A SHADOW BOX IS A SHALLOW, RECTANGULAR BOX USUALLY USED TO DISPLAY KEEPSAKES, BUT IT ALSO MAKES A PERFECT SPACE FOR AN ASSEMBLAGE. I love being able to create my own shadow boxes out of an art canvas and lattice molding. They are cheaper than the ones you might buy at the store, and you can customize the size.

For this project, I thought it would be interesting to make a doll out of assemblage materials. Dolls make wonderful subjects for assemblage because you can make your figure out of just about anything. This playful and quirky little girl is a fun combination of flat images and three-dimensional objects. Use your own materials and see what you create.

you will need

shadow box frame (use a cigar box or turn to page 17 to learn how to make one) ★ acrylic paints: light ultramarine blue, cobalt teal, yellow ochre and pyrrole red ★ paintbrushes ★ doll body parts, game pieces or other found objects ★ various collage items ★ gel medium

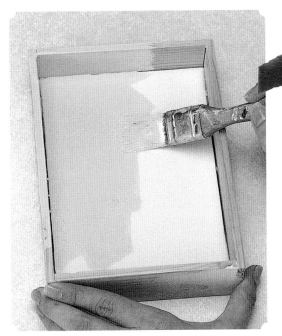

one

Paint the Inside of the Box

Choose a shadow box for your assemblage. You can make your own by following the steps on page 17, or you can use a cigar box or other wooden box instead. Make sure it is clean and sanded, then paint the entire box, inside and out. I am starting with a handmade shadow box. I think I want the background of this piece to be a very pale blue, so I paint the box with Light Ultramarine Blue acrylic paint.

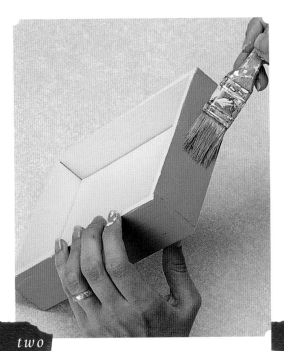

two

Paint the Box Frame

Add a little more contrast to your box by painting the out-side of the box a different color. This box looks a little too pale, so I am painting the outer part of the frame with Cobalt Teal.

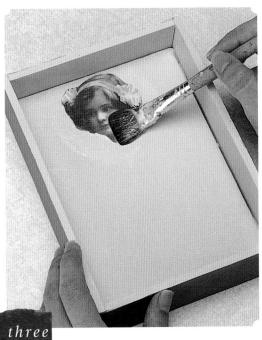

three

Paste Down the Head

Pick out a head for your doll. This could be either a flat image or a three-dimensional object. You might substitute something whimsical, like a shell or ball of twine, for an actual image of a head—whatever suits you.

I am beginning my "doll" by pasting on a little girl's face. I have a pretty good idea where I want this piece to go, so I glue her down with gel medium at the top of the shadow box. If you want to try arranging several pieces first, before you glue anything down, that's fine, too.

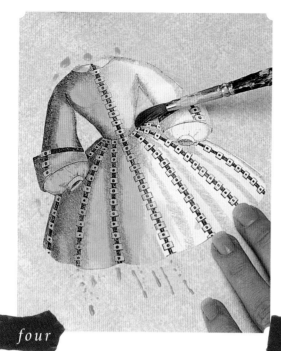

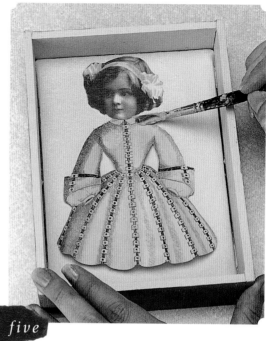

four

Find More Elements

As you look at the materials you have available, ask yourself whether you might want to modify any of them first. Choose one or more items to form your figure's body. I want to give the little girl a dress, but the only image that I have is a photocopy and it's too white. I give the photocopy of the dress a light wash with Yellow Ochre paint, to give it a tea stain effect.

five

Paste the Body in the Shadow Box

Arrange the pieces that form the torso of your figure in the box and glue them down with gel medium. Notice that in my case I make sure to glue only the top half of the dress down so that I can insert legs under the full skirt later.

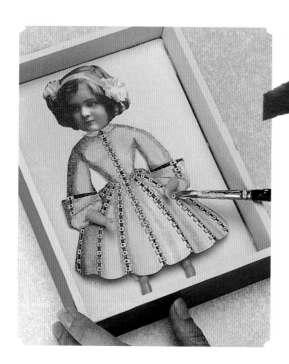

six

Finish the Figure

How does your figure look so far? My little girl needs some arms and legs! I found some doll parts in my stash of things. I glue the legs down under her dress and the arms so that they look like they are coming out of the sleeves. Try a similar combination of flat and dimensional elements.

⭐ **add another dimension** Using canvas as the back of your shadow box has its creative advantages. You can cut or sew through the background and add objects and elements in interesting and surprising ways. For example, you could stitch a beaded necklace around a doll's neck or cut a little door out where her heart belongs.

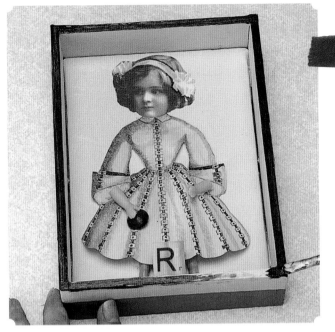

Add More Color

Now that your basic doll is finished, step back and look at your assemblage again. Does anything seem to be missing? Would it help to add more color or texture in some spots? Make any changes necessary.

This piece feels too blue. It needs some "punch." I add a little red game piece to the doll's hand and then taking the cue from the red, I add the letter **R** to the bottom of the box. Finally, I paint the frame edge Pyrrole Red to match.

★ what if?

>> What if you rusted her dress?

>> What if you glazed over the background in a deeper color?

>> Where would you add more texture and how?

>> What if you substituted other objects for the arms and legs?

>> What words are in your collage stash that might add more personality to your piece?

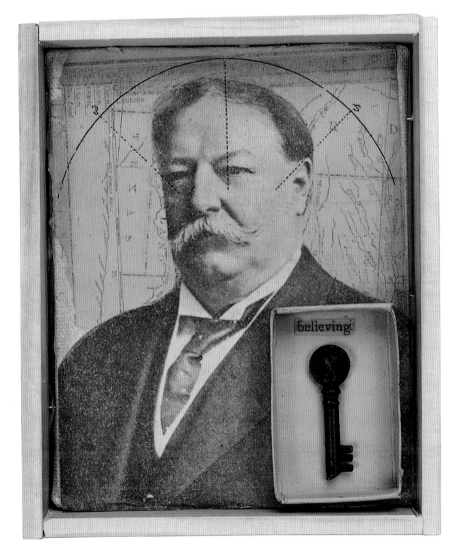

Believing 5½" × 4½" × 1" (14cm × 11.5cm × 2.5cm) This shadow box was made by framing an art canvas. The small matchbox with a key inside makes this piece much more visually interesting than if it were made only of flat images.

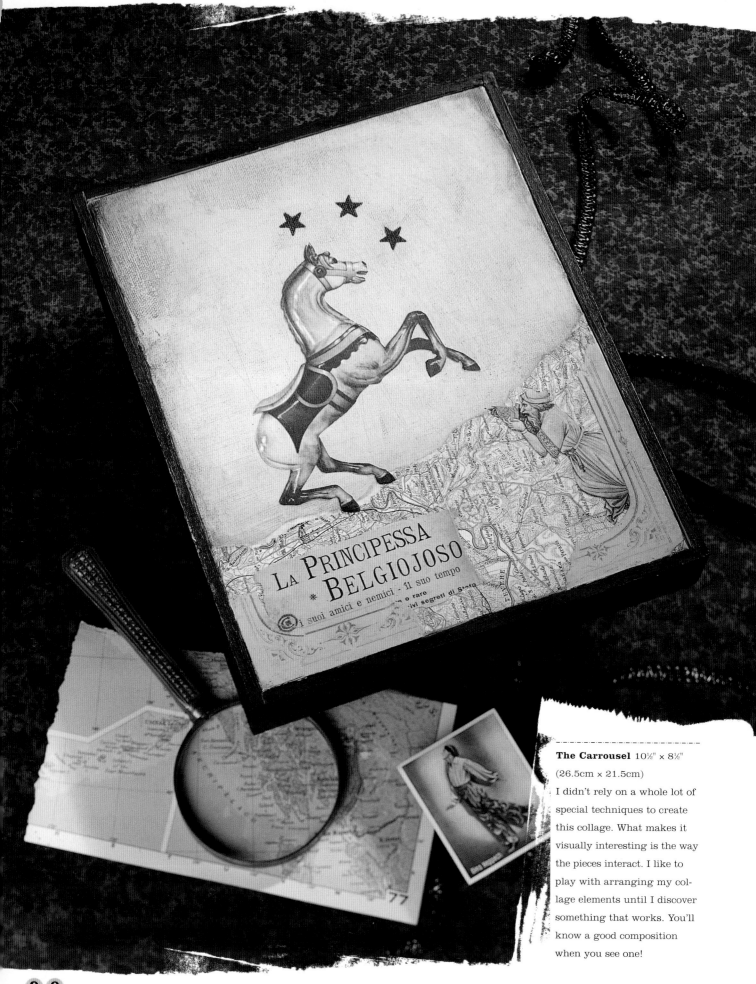

The Carrousel 10½" × 8½"
(26.5cm × 21.5cm)
I didn't rely on a whole lot of
special techniques to create
this collage. What makes it
visually interesting is the way
the pieces interact. I like to
play with arranging my col-
lage elements until I discover
something that works. You'll
know a good composition
when you see one!

PLAYING WITH *composition*

We know it "works," but we can't always say why or put our finger on the exact reason we feel it is so successful.

A work of art is usually successful because it has a successful composition of elements that convey a contextual meaning to you, the viewer. The way the elements are arranged directs your eyes' movement through the piece of art and holds your interest.

We all know when we see a piece of artwork that is successful.

I want to show you that you do have intuitive knowledge about placement and what looks good. Deep inside, you do know how to create a good composition; all you need to do is focus your energy. In the next three exercises,

I'll show you a random assortment of collage elements on a canvas and we'll work on adding, subtracting and rearranging elements until we have a composition that we truly like. You are encouraged to adapt these exercises to use whatever materials you have on hand. Along the way, pay attention to the questions I want you to ask yourself. They will help you improve your powers of observation and learn to make the right choices about your art.

Next, I will introduce you to some creative journaling prompts and exercises designed to further develop your intuition about composition and what makes a good-looking collage. Writing about your work may seem like an unusual way to become a better collage artist, but keeping a journal can have a dramatic impact on your creativity. Try it for yourself and see!

it's good to be king

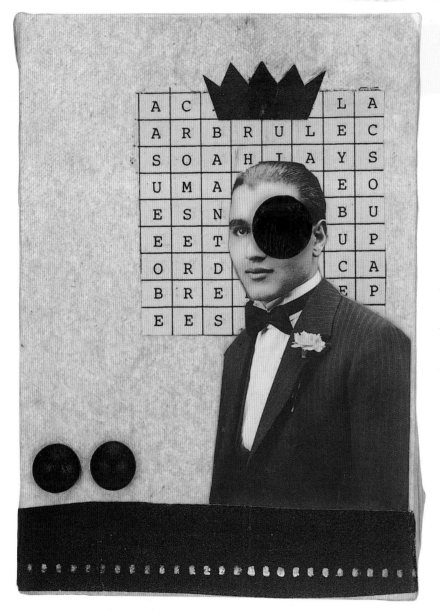

NOW IS THE TIME TO ENLIST YOUR POWERS OF OBSERVATION! We'll start with a jumbled-up composition and try to make it work. Take a good look at each illustration and answer the questions about where this composition is headed before you go to the next step. See whether you come up with the same solutions as I do.

you will need

5" x 7" (12.5cm x 18cm) art canvas or other surface ✶ collage elements: words, stamps, scraps of maps, pages from books, words, diagrams, etc. ✶ copies of clip art and vintage photos ✶ found objects: buttons, game pieces, nails, small bottles, lace, etc. ✶ brushes ✶ gel medium ✶ acrylic paint ✶ scissors

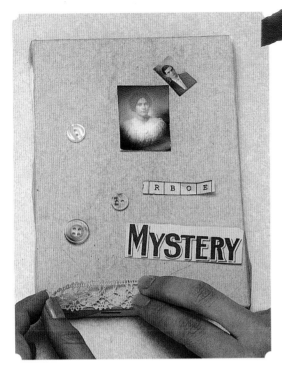

Assess the Initial Composition

Close your eyes for ten seconds and then open them. Now look at this composition. What is the first thing that you notice? Where do your eyes go first? What would you do first to improve it?

When I first look at this surface, I see lots of tiny images just floating around. None of the items seem to relate to each other. Notice how your eye doesn't know what to look at first in this composition; it sort of hops around looking at everything. There is no one element that pulls your eye in and says, "Hey, look at me!"

Let's begin by creating a better focal point. This is the single image that attracts your eye first. Can you envision adding a collage piece that would make a good focal point in this composition? The easiest way to create a focal point is to pick a subject that is big or that uses a color that attracts your eye.

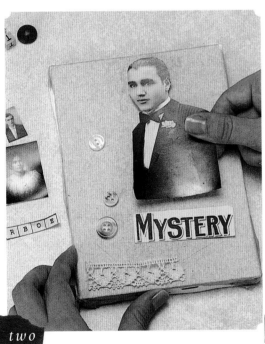

two

Create a Better Focal Point

I decide to replace the two little photos with a larger photo that takes up more space on the canvas. See how right away this adds a nice harmony to the piece? Your eye feels more relaxed because it knows where to look first.

Look at this composition again. We have a focal point. How well do the remaining elements relate to each other? Are there pieces you think work well with the subject and others that do not matter? What elements would you leave in or take out?

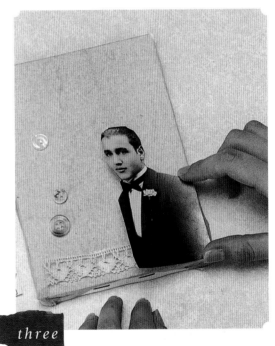

three

Take Out the Unnecessary Elements

I have decided to remove the word **mystery** and the strip of letters. I can always add these elements back in later, but for right now they are not working for me. I also didn't like how the man was just floating in the middle of the canvas, so I shifted him down to the lower right corner.

Take a good look at the collage now. Do you like where the elements are placed? Could any of them be moved to a better spot?

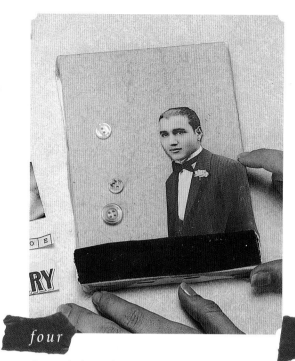

four

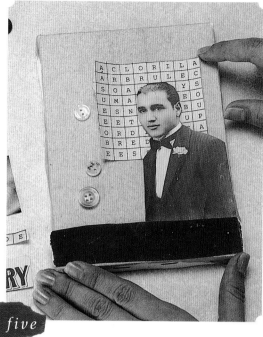

five

Ground the Subject

The man in this composition seemed like he was too low on the canvas to be the center of attention. I wanted to lift him up and make him take up even more room in the collage. One way to keep him from looking as if he is floating is to create a horizon line or a "ground" on which to place him. I move the man up and add a strip of black paper to the bottom of the canvas. See how this grounds the man and gives him something to rest on?

So far, we have taken several items out of this composition. Is anything missing? Are there any new items you would add at this time? As you choose what to put in your collage, think about how it relates to the main focal point.

Add New Elements

I decide to add something that will draw attention to this man's head so that everyone knows he is important to the composition. A patterned background would help. I cut a square out of a word finder puzzle and add this behind the man's head.

Study the overall design again. Do you think the pattern behind the man's head helps this composition? Do all the remaining elements work in harmony? What would you change next?

★ **is it necessary?** Each time you consider adding a piece to your collage, ask yourself whether it is necessary. You don't want to add a piece just because it is interesting by itself. It should connect with the rest of the elements already there.

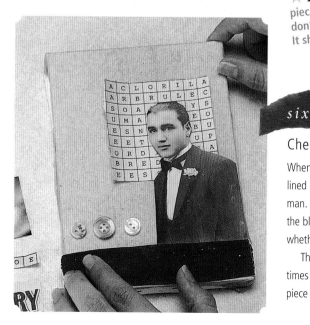

six

Check the Overall Design

When I looked at the composition, it bothered me that the buttons were lined up vertically. They seemed to distract attention from the image of the man. Here, I move the buttons down and line them up horizontally along the black horizon line. Anytime you add or remove an item, ask yourself whether you need to make other adjustments as a result of the change.

The composition is looking much better, but it's a little boring. Sometimes a composition can be good but still lacking in some way. Does this piece need more color or texture or contrast?

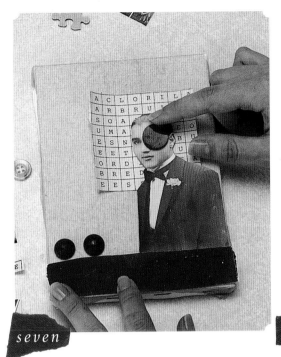

seven

Ask What More is Needed

I want to add more color, so I switch out the cream buttons for little red game pieces. I decide to move one of them onto the man's eye for some whimsy. This also directs the attention back to the image of the man. This is much better!

At this point in this exercise you might ask yourself, Who is this man? What kind of person is he? If the subject of your collage is lacking in personality, look for embellishments that might enhance it. What words or symbols would make this man more engaging?

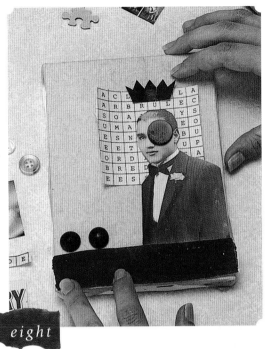

eight

Enhance the Story

I notice that the word **rule** is directly above the man's head in the word finder puzzle. To play off this theme, I add a crown that I cut out of black paper above the man's head. Now he seems to have a bit of history.

This collage is just about finished. Notice your eye's movement within this artwork. You'll see that your eye goes to the man's face with the red circle first, then up to his crown, then back down to the two little red game pieces, and then back up to the man's face again. This composition is successful because it moves your eye around the piece and keeps you interested.

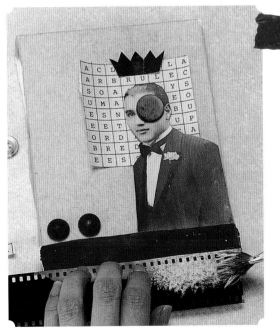

nine

Add the Final Touches

Maybe you think this collage looks finished by now. That's perfectly fine. When a collage looks good to you is when you should stop. Still, I decided that this piece needed just a little something extra added to the bottom of the composition. It felt a little blank to me with just a big black strip of paper along the bottom. So I use leftover film as a stencil and brush acrylic paint over the film holes to add square spots to the bottom strip.

★ write about your work
Whenever you finish a collage, take some time to make a few notes about what you like about it. Think about what you would improve if you could. Look back on these notes when you work on other collages and see what insight you can gain from them.

Vacation

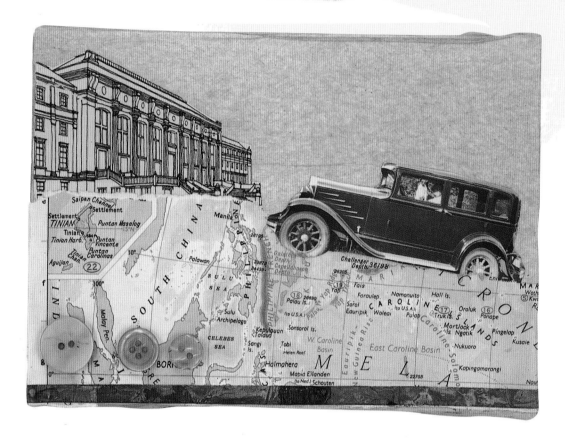

HERE IS ANOTHER COLLAGE PIECE THAT STARTED OUT NEEDING A LITTLE HELP. As we work at fixing a mixed-up composition to get to this finished piece, I will ask you many of the same questions that I asked in the previous exercise. See what solutions you come up with this time. Even if you consider an approach different from the one I offer here, you can still learn some of the composition tricks that work best for me, then try them out in your next collage.

you will need

5" x 7" (12.5cm x 18cm) art canvas or other surface ✫ collage elements: words, stamps, scraps of maps, pages from books, words, diagrams, etc. ✫ copies of clip art and vintage photos ✫ found objects: buttons, game pieces, nails, small bottles, lace, etc. ✫ paintbrushes ✫ gel medium ✫ acrylic paint ✫ scissors

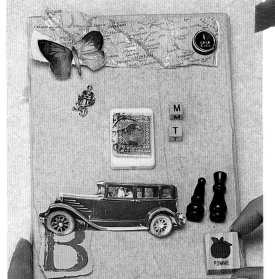

Assess the Composition

Close your eyes for ten seconds and then open them. Now look at this composition. What is the first thing that you notice? Where do your eyes go first? What reaction do you have? What would you do first to improve it?

The first problem I notice is that there is no true focal point. The car is the biggest element on the canvas, but several other items fight for my attention. That is a big problem. Without a focal point the artwork lacks interest. I also notice that none of the items seem to relate to each other. They don't offer the viewer any clear message.

Let's start with a focal point. Which image would you choose as a focal point? What would you do to give it more attention? Does it need more space around it? Does it need to be moved to a better position in the collage?

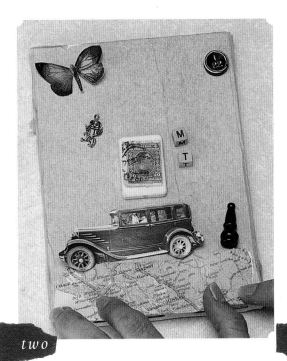

Create a Focal Point

I think I will use the car as my central image since it is the biggest element on the canvas. To draw more attention to it, I remove the letter and the little tomato from underneath it and pull the piece of map to the bottom of the canvas. Notice how right away this helps ground the image of the car and also draws more attention to it at the same time.

Look at the composition now. Is it still crowded? Are there any pieces that don't seem to contribute to the overall design? Which elements would you keep? Which would you drop?

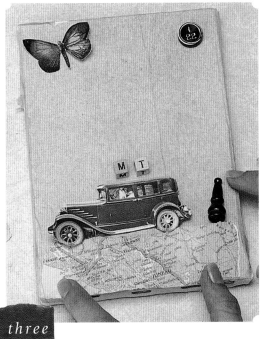

Take Out Unnecessary Elements

The blank domino, postage stamp and metal charm floating in the middle of the artwork aren't lending anything to the message of the piece, so I remove those to create some space.

What do you think about the composition now? Where does your eye go? Which pieces would you remove or rearrange right now?

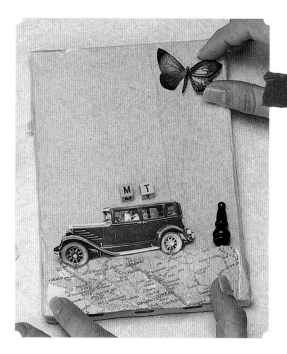

Improve the Balance

Since there was an object in every corner of this canvas, I decide to remove the bingo chip and pull the butterfly to the other corner. Sometimes an odd number of key elements helps make a piece a little more dynamic.

Study the composition again. What do you like? Is there anything that doesn't work that you would change? Using the elements we have here, would you change the composition in any way?

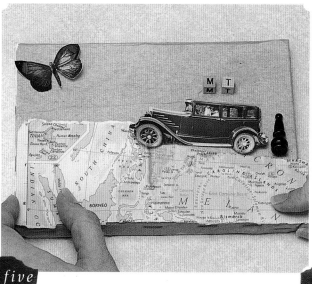

Switch the Format

The car felt a little crowded to me with the canvas in a vertical format. It looked like it was about to drive right off the edge of the piece and was leading the eye right out of the artwork. So I switched the composition to a horizontal format, and everything seems to have a little bit more space. Now the car has some room and doesn't lead the eye off the edge of the canvas.

Now look at the theme or story this collage is telling you. Where is this car going? What elements could you add that might suggest a destination? What elements would you remove because they don't relate to your story?

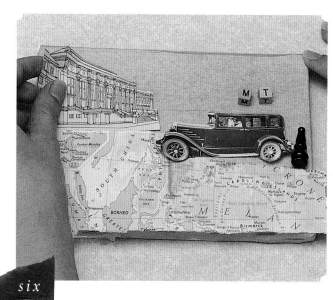

Enhance the Story

While I liked the butterfly, it felt out of place in this composition. It didn't add to the story that I wanted to tell. I decide to replace the butterfly with a cutout of a building. Now it feels more to me as though the car is driving across a landscape with a building in the background. With the building in the background, the letters ⓜ and ⓣ and the chess piece no longer help the message of the piece, so they will have to go.

Now is when I like to look at adding more color or texture in a way that doesn't detract from the story. Small embellishments can add both. What found objects would you consider using?

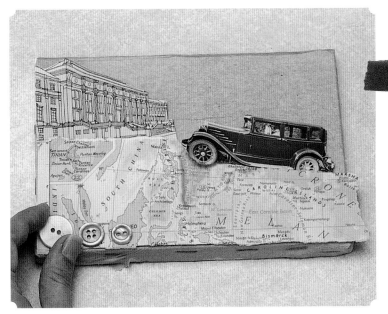

Add Color and Texture

I decide to add a little row of buttons that complement the map at the bottom. This seems to add a nice little touch and a little bit of interest in that corner. At this point the piece looks close to being done. This is a good time in any collage to step back and assess it one more time. Note anything that seems missing or out of place and make any necessary adjustments.

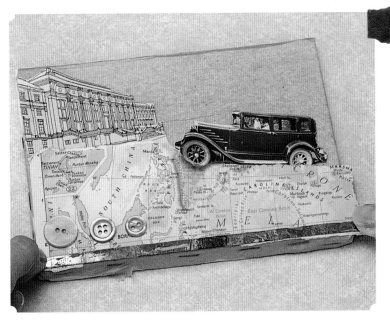

eight

Add the Final Touches

I felt that the buttons were too close to the bottom of the canvas and the canvas still needed a final grounding element. I have a strip of copper tape that I aged with a Patina Green solution. This seems the perfect final element to ground the canvas, and I move the buttons just above it to complete the composition.

You'll notice that your eye now goes to the car first, then to the building, then to the little green buttons, and then it follows the copper tape back over to the car. This composition works because it moves your eye around the piece and holds your interest within the artwork. There is no more clutter and the elements all come together to convey a cohesive message.

★ **try it yourself** I encourage you to create composition exercises like this for yourself. Start with a plain canvas painted a neutral color as your base, use a variety of elements and move them around without gluing them down. Write in a journal about the progress of your piece, why you chose to add or take out elements and what you think you did that made your collage better in the end. You will be amazed by how much you can learn this way.

infinite **tragedy**

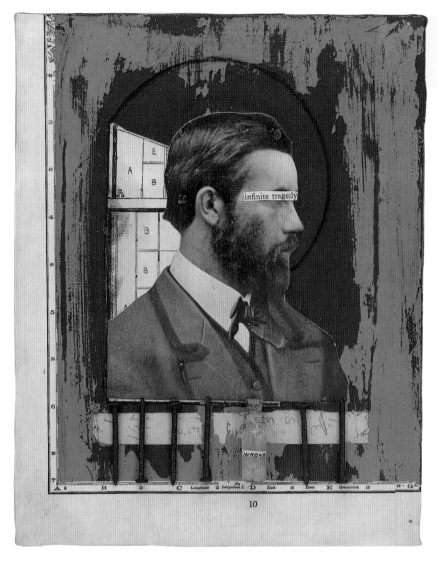

T HIS ARTWORK IS ONE THAT I STARTED SOME TIME AGO. When I abandoned it, I was not happy with it at all. The main figure was floating, centered in the middle of the canvas. This makes for a rather boring and predictable artwork. Perhaps you have a collage piece that needs a fix, too. Even though everything is already glued down, it can be helped! In this section I demonstrate a few techniques for improving a flawed composition that is already glued into place.

 you will need

5" x 7" (12.5cm x 18cm) art canvas or other surface ★ collage elements: words, stamps, scraps of maps, pages from books, words, diagrams, etc. ★ copies of clip art and vintage photos ★ found objects: buttons, game pieces, nails, small bottles, lace, etc. ★ paintbrushes ★ gel medium ★ petroleum jelly ★ acrylic paint ★ scissors ★ colored pencils

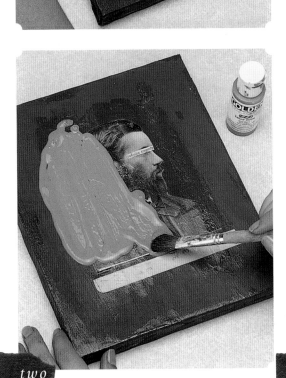

one

Decide What Has to Change

Here, I have an image of a bearded man glued onto a red canvas. Over the man's eyes, like a tiny blindfold, I had pasted the words **infinite tragedy**. Do you have a tragedy piece of your own that you have started but set aside? Take it out and ask yourself what is working and what isn't. Think of what techniques were presented in the front of the book that you might use to improve the design in any way.

In this case, I have a good focal point, but he is floating in the center of the canvas with nothing to ground him. I think a peeling paint background might add some interest to the large border around him. If the peeling paint technique will help your piece, apply petroleum jelly as I am doing here to the areas you want to protect from the paint.

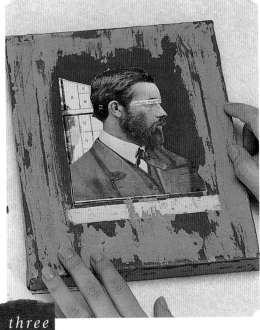

two

Add Paint in a Contrasting Color

Cover with paper or paint any areas of your collage that aren't working. These could be areas that are either too busy or too plain, depending on your composition. Choose colors that work well with the other elements in the composition.

I choose Yellow Ochre as my color, and since I am doing the peeling paint technique, I cover over the entire collage. Once it is completely dry, I will peel off the paint lying over the petroleum jelly to reveal the images beneath it and wash any remaining jelly off the canvas.

three

Review the Changes

Now that your changes are made, step back and take a good look at your collage again. Does it look any better than before? Are the elements more in harmony with each other? Did the technique you used add more color or texture where it was needed?

Look at this composition. The peeling paint created a nice weathered border around the man. The ochre color contrasts with the red underneath, which helps lighten the artwork. Do you think this is an improvement? Does this composition need something more?

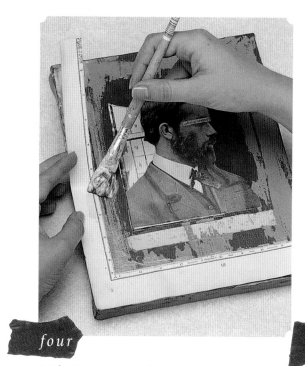

four

Make Necessary Adjustments

Examine each area of your composition and decide whether there are spots that need more work. This piece still needs something to tighten it up. I find an old map border, and I paste it on the side of the canvas. This helps tighten the composition and relates to the diagram elements in the center of the canvas.

five

Add Related Elements

Does your collage need some additional dimension or texture? Sometimes a single found object or a row of beads can make a dramatic difference. They can emphasize the story of your collage in interesting ways.

To play on the tragic theme of this collage, I decide to glue on a few nails I rusted using the bleach and vinegar method and a bottle with a verdigris patina. I align them so that they touch the paper border at the bottom. This helps to integrate the elements a little better.

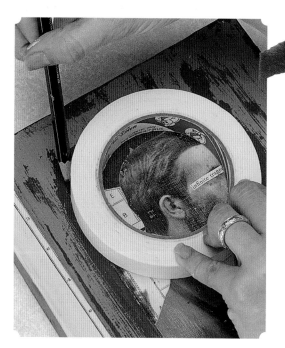

six

Add the Final Touches

When you are close to finishing your collage, step back and review it once more. Is the focal point easy to spot? Do the supporting elements relate well to each other? Is your eye constantly engaged? If you have accomplished all that, then you have created a successful collage!

I decide that my tragic man still needs some sort of element that will connect the architectural papers behind him to the rest of the composition. A halo will do the trick, and I add it by tracing around a roll of masking tape with a black colored pencil. Look back at the final image on page 100. Is this now a successful collage?

{Composition Tips}

OR WHAT TO DO *when you're stuck*

>> Create a Strong Focal Point A focal point is the first thing your eye goes to in a composition. A good focal point draws your attention to the most important thing in your artwork. One quick and easy way to guarantee that you have a strong focal point is to choose an image that takes up at least half of the space on your collage surface. This will create an instant focal point because its size will automatically grab your attention no matter what other smaller elements you put on there.

>> Use Elements That Support the Main Image Always keep in mind that you want collage elements to go with the story or purpose of your piece. It will help you decide whether to keep an element in or leave it out. Pick a collage element that you think might work in your collage. Experiment with adding it to your composition. Does this piece add to your focal image? Does it help you to tell a story? Continue adding supporting elements until you feel that you have told the story you want to tell with your artwork. Perhaps it takes only one or two supporting elements.

>> Don't Overcrowd Your Artwork Don't use all your favorite elements in the same piece. Just because you like something doesn't mean it's meant to go in that artwork. Usually, only three supporting elements are enough. If you take an item away, do you miss it? If you don't miss it, then that means you don't need it. Remember that less is more! In other words, don't cram a piece into a collage just because you want to use it. Maybe it's meant to be in another creation all its own.

>> Vary the Size and Shape of Your Elements Remember, variety is the spice of life! You don't want all the elements to be the same size and shape. Then they will fight with each other for attention. Variety of size and shape will keep things interesting!

>> View Your Art From a Distance View your work from a distance to get a different view of it. Squinting is also a good way to look at your artwork with new eyes. If that doesn't work, get away from your piece and let it rest for a couple of days. When you come back to it with fresh eyes, you will more readily notice if something looks amiss to you.

>> Work on Several Collages at Once If a collage isn't quite working for you, set it aside and start another one. By the time you come back to the first piece, you might have a clearer idea of where you want the collage to go.

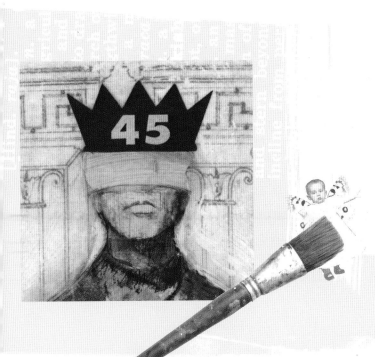

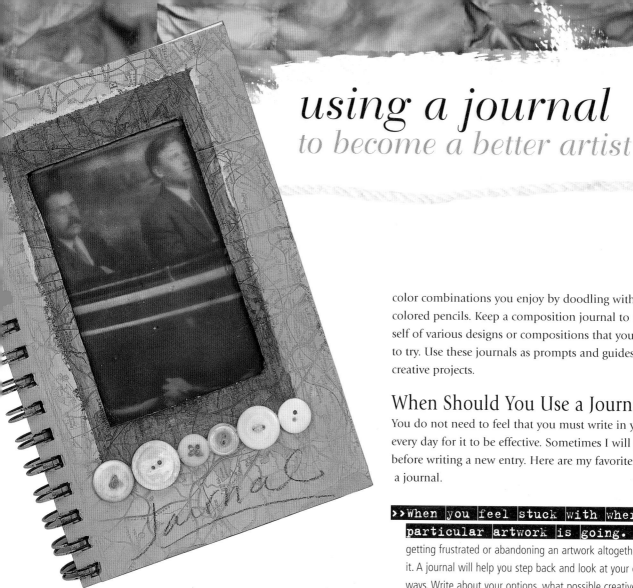

using a journal
to become a better artist

color combinations you enjoy by doodling with paint or colored pencils. Keep a composition journal to remind yourself of various designs or compositions that you would like to try. Use these journals as prompts and guides for future creative projects.

When Should You Use a Journal?

You do not need to feel that you must write in your journal every day for it to be effective. Sometimes I will go weeks before writing a new entry. Here are my favorite times to use a journal.

>> **When you feel stuck with where a particular artwork is going.** Instead of getting frustrated or abandoning an artwork altogether, write about it. A journal will help you step back and look at your creation in new ways. Write about your options, what possible creative solutions you might try.

>> **When you see the work of other artists you admire.** You do not have to copy other artists' compositions. Simply use their art as a tool to train your eyes. You will learn more about what you like and what you think is successful art.

>> **Whenever you finish an artwork of your own.** Write not only about what you think is successful but what you think doesn't work and how you think it could be improved. What mood does your work convey? How does it make you feel? What messages were you trying to send to your viewer?

Why Journal About Your Art?

You can learn a lot about yourself and how you create your artwork through writing about it in a journal. Use a journal to write about your collages when you are having trouble with them, or to write down your first impressions when you have finished a piece. Use a journal to reflect about the creative process, the elements and techniques that you used, what works for you and what doesn't.

When you keep a journal about your art, it becomes an amazing resource. When I have trouble with a particular work, I will look back in my journal to a work that is similar and see what I wrote about. Sometimes just looking back through my journals will spark ideas as to what I could improve or what might not be working for a particular piece.

You can also keep color or composition journals. Fill the color journal with paint chips and fabric swatches or explore

Writing about all these things will help you to become closer to your artwork and will aid you in paying more attention to what you do! Focus is the key. Through writing and observing, you will grow as an artist. Even the best artists have room to learn from themselves and others!

Creative Journaling Prompts

If you have never used a journal to improve your artwork, you may not be sure how to begin. To get you started, here are several good exercises and questions that have helped me become a better artist.

•• Pick out one of your own creations and place it before you. Close your eyes for ten seconds and open them very quickly. What catches your eye first? Where does your eye go next? Write down everything you notice.

•• Study one of your works and note the colors you used. Which colors are dominant (used the most) and which are subdominant (used to back up the dominant color)? If you wish, keep a separate color journal and paste in it swatches of paint or color combinations you like the most.

•• Look at the sizes of the elements in your collage. Are they different or all the same? Do they have enough space, or are they too crowded? Imagine taking one element out. Would you miss it? Do you need to make something bigger?

•• Observe one of your works and write what you feel it is about. What were you trying to say when creating this piece? What do you think a viewer might see in the work?

•• Take a look at a piece of your artwork that you are not completely happy with. Write about why you do not feel this was a successful piece. What could be done to improve the piece?

•• Study a work of art by an artist you admire. Write about the first thing your eye notices when looking at the artwork. Where does your eye move after that? Why do you enjoy this artist's work? Are you captured by the imagery? Is it the composition? The colors? What do you see in their work that you wish you could see in your own work?

•• Open your dictionary to a random page, choose a word and write about how the word makes you feel. Do you get any visual images from reading the word? Could you use these images to enhance one of your collages?

•• Write about a dream that you recently had. Would it be possible to re-create part of this dream in a collage? What was the dominant feeling of the dream? If you had to assign it a color, what color would it be?

•• Choose one of your collage elements that you have not yet used and write about it. If you were to use this element in a piece of your artwork, what might the story be? Why does this element intrigue you?

•• Go through your collage supplies and quickly pick out five elements. Don't worry about how they relate, just pick at random. Spread out the elements that you have chosen and write about them. What comes to mind when first looking at them as a grouping? Is there a story to these pieces? Could they work together as a collage?

Musiciens-Poetes
6½" x 2" x 1½" (16.5cm x 5cm x 4cm)
Domino boxes make wonderful spaces for assemblage. Rusted wire and nails were combined with a contact paper transfer to complete this piece.

I think one of the main problems that most people have with composition is that they stay too far away from their subject matter. They work with items that are too small for their surface, and everything looks tiny and floating in their art projects. Here is an excellent exercise you can use to train your eye to get closer to your composition, and by doing that, you'll learn to create more dynamic collages.

For this exercise, you will need a stack of images, an empty slide mount to use as a viewfinder and some scissors. In the demonstration shown here, I use old photographs, but you could also try this exercise with magazine images, your own photos or clip art. If you don't have a slide mount, you can use a piece of paper with a rectangle cut out of it. It doesn't have to be fancy to do the trick.

Try keeping a journal of your composition exercises and photocopied enlargements as inspiration when you are working on new collages. If you feel stuck as to what direction your composition might go, you can pull out your journal and pick one of your exercises and develop that into a larger composition.

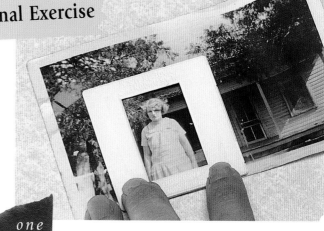

one

Look for Images in Your Viewfinder

Choose a large photograph or drawing with a lot of interesting elements and place your slide mount on top of it. As if you had a tiny camera, move your viewfinder around until you find a composition that you like. Notice how different the smaller, more focused composition is from the larger photograph. In this first shot, I have placed the woman in the center of my frame. It creates a nice image, but it's kind of predictable. We can make this better.

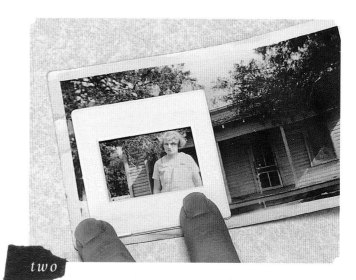

two

Change the View

Shift your viewfinder around again. Change the orientation. Crop a common subject in an unusual way. See what visual surprises you can uncover. Notice what happens when I push the subject all the way to the right. Now the background behind the woman becomes part of the composition. What do you think of this image? This is more interesting, but the tree and shadows behind the woman seem to draw our attention away from her.

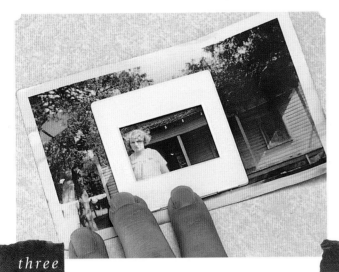

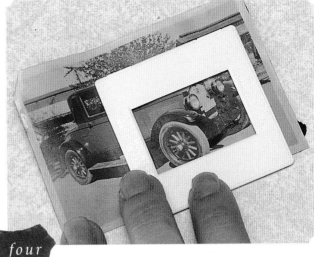

Explore Alternate Compositions

Search for more compositions until you find one that appeals to you. In this third composition I moved the subject all the way to the left—and a more interesting composition is created. I like the geometric elements that the house behind the woman creates, yet the woman still remains the center of attention. It looks very interesting.

Play With Abstract Shapes and Patterns

For another variation on this exercise, try finding interesting shapes within a subject. Move your slide mount across an image of a common object. Don't look for elements that are necessarily recognizable. Notice what happens when we crop in tightly on the tire and front of an old car. You are no longer seeing a car; you are seeing a fascinating combination of shapes and patterns. I like the mixture of curves and areas of light and shadow in this piece.

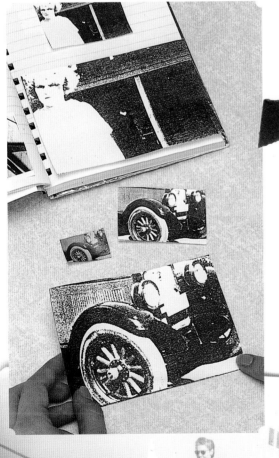

Save the Images You Like

When you find a composition you like, trace around the image and cut it out. Enlarge it on a copier machine. Make note of how it changes or becomes more abstract as you enlarge it. This can help you look at the image in new ways. Paste it into your composition journal for inspiration. Refer back to the images you liked most when you are looking for ideas for your next collage.

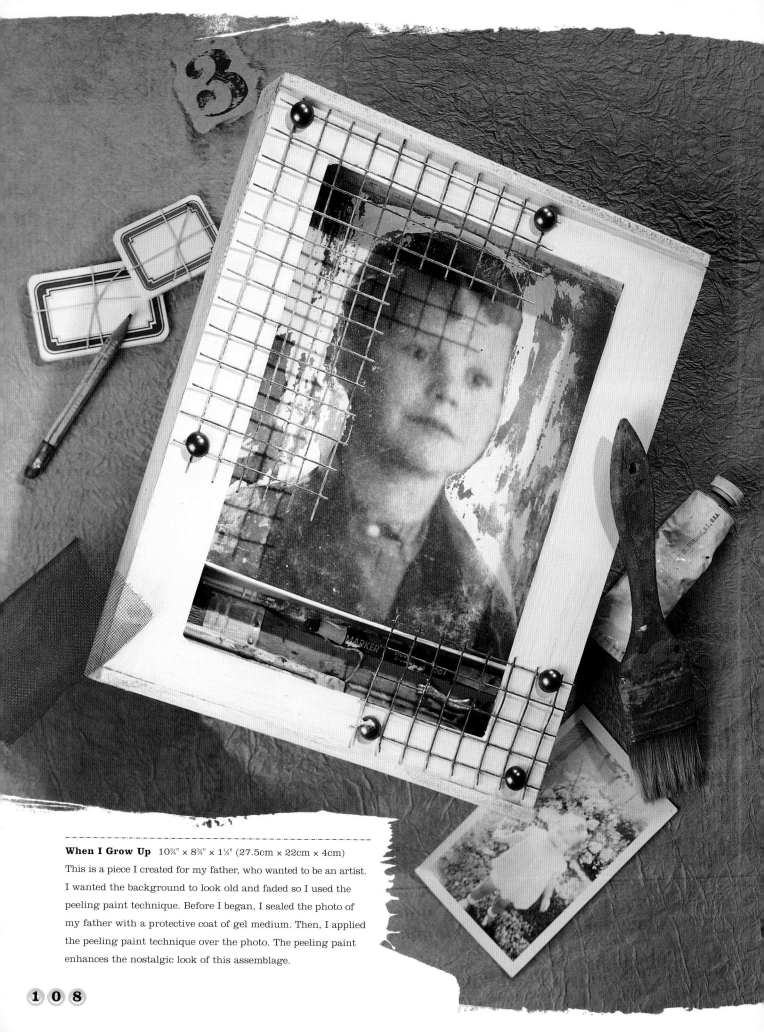

When I Grow Up 10¾" × 8¾" × 1½" (27.5cm × 22cm × 4cm)
This is a piece I created for my father, who wanted to be an artist.
I wanted the background to look old and faded so I used the
peeling paint technique. Before I began, I sealed the photo of
my father with a protective coat of gel medium. Then, I applied
the peeling paint technique over the photo. The peeling paint
enhances the nostalgic look of this assemblage.

storytelling WITH COLLAGE

Perhaps your photos are sitting in boxes or heavy albums, unloved and neglected. Why not pay tribute to members of your family by creating collages using elements from their past? Why not celebrate a close friendship by giving a collage that uses images of times shared together?

Where are the old photos of your relatives?

The assemblage on the facing page is a piece that I did in tribute to my father. He comes from a long line of Hellmuths who wanted to become artists but instead became architects so they would be able to "earn a living." I felt sad that he had left behind his painting and drawing. I wanted to express this in a collage. I used an image of my father as a little boy, and I placed old paintbrushes and pencils in a cage below him to represent what he left behind in order to lead a responsible life.

It is fascinating to reflect on people's lives and try to express the essence of a person in a collage or keepsake assemblage. These pieces make amazing gifts for birthdays, anniversaries, family reunions and other occasions. I suggest that you try to create some collages with your family members in mind. You will create a meaningful reminder of their personal history.

This section will give you a few ideas about how to create a heritage or keepsake collage of your own.

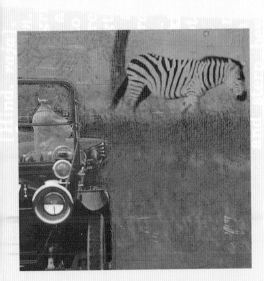

collage *storytelling basics*

Collage is special because it allows you to create personal works of art. Many of the images and objects used in collage are gathered from the stuff of our everyday lives: clothing, photographs, letters, toys and games, invitations, jewelry, ticket stubs, household objects—the list could go on and on. So many of these items have stories and memories attached to them. Place these items into a collage or assemblage and the story you tell can be quite powerful.

To get you started, here are the basic steps for telling a story in a collage. Once you have picked a subject and gathered your materials together, follow the demonstration on page 112 for further inspiration.

STEP ONE >> Choose a Subject

Who or what is your subject matter for this collage? Heritage collages honoring a favorite grandparent or a fiftieth wedding anniversary are some of the most popular collage themes you might try, but don't stop there. Celebrate a close friendship. Commemorate a favorite pet or the first home you ever owned. Use collage elements to re-create the mood of a special place or time in your life.

STEP TWO >> Brainstorm About the Subject

If your subject is a person, list all the things that come to mind when you think of this person. Can you think of specific words that the person said often? Perhaps you could include these in your piece.

If it's a place (like your childhood home), list all the memories that come to mind when you think of that place. If it is a specific event, situation or mood that you would like to pay homage to in your collage, try to conjure up as much as you can about that event and write it all down.

STEP THREE >> Look for Elements That Tell Your Story

Extract elements from your writing to use in your collage. Perhaps you remember that your favorite house always had a broken lock on the back door; maybe you would include a key or a lock to reference that in your piece. Try to look past the obvious.

STEP FOUR >> Create Your Collage

Create a collage or assemblage using the elements you have gathered. Consider making your collage on a canvas if you plan to frame it or give it as a gift.

themes you might try

>> Your pet
>> Anniversary
>> Birthday
>> Wedding
>> New baby
>> Travel/vacation
>> Friends
>> Family
>> Homes you have lived in

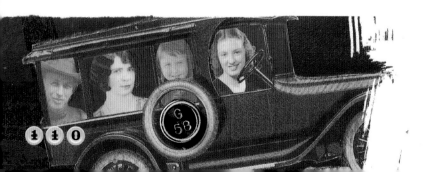

Capturing the Mood of a Place or Time

This piece is a wonderful example of a collage that tells a story about a certain place and time. I was asked to create a series of artworks to go with a line of Hemingway furniture. I decided to focus on the travel aspect of Ernest Hemingway's life. This collage represents the time he spent in Africa in 1933.

What would you have included in this collage? I gathered together an old map with the continent of Africa, an image of zebras walking in the bush (which I colored sepia on my computer and then printed out to later use as a transfer), airmail letter stripes, a postage stamp with a rhino, and animal print fabric. Lastly, I managed to find an old photo of a woman in a car that looked to me as though it could be a jeep. The jeep looked as if it were a car on safari. By combining all these elements into one collage, I was able to successfully evoke the exotic mood of a bygone era. No matter what place or time you wish to evoke in your collage, look for elements that will reflect it.

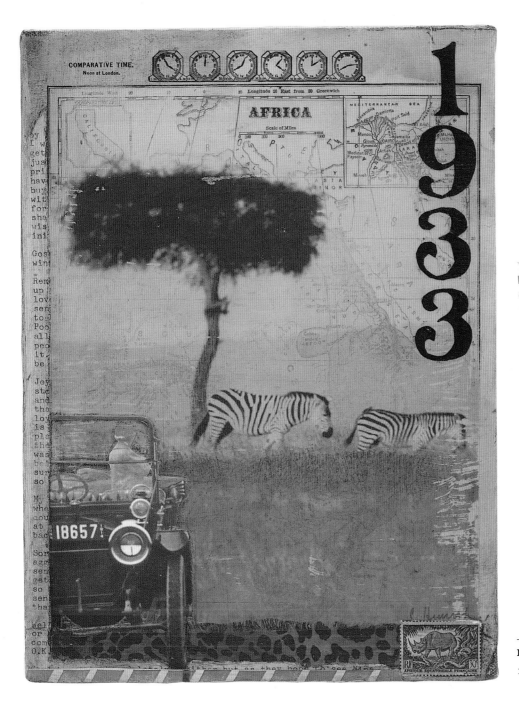

★ **use color copies**

If you do not want to use actual photos in your collage, simply make color laser photocopies onto heavyweight card stock at your local copy center. Card stock will make the photos nice and sturdy, and the copies will look just like the real thing.

Hemingway: Africa, 1933

12" x 9" (30.5cm x 23cm)

first Cousins

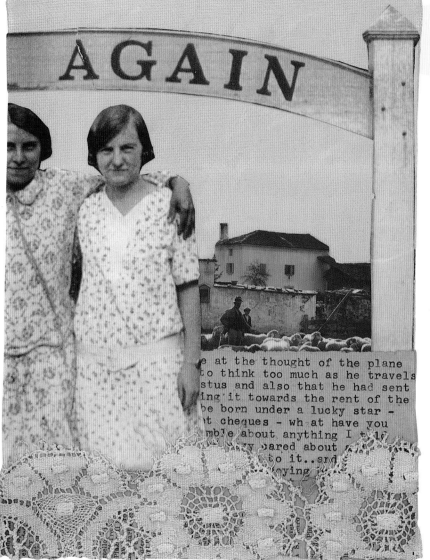

I OFTEN CREATE HERITAGE COLLAGES ON COMMISSION. I love working on these commissions. They give me an interesting glimpse into other people's lives. I enjoy the challenge of arranging collage elements in ways that capture the spirit of a particular person or place.

This piece commemorates two cousins. Each summer, when they were young, they used to spend a few weeks together at an uncle's ranch. This collage expresses the friendship that grew between them during that time. If you have someone close you would like to honor, gather together some images and objects that remind you of that person and follow along with this exercise. It will give you some ideas about how to create your own heritage collage.

you will need

5" x 7" (12.5cm x 18cm) art canvas ✳ acrylic paints ✳ paintbrushes ✳ gel medium ✳ assorted keepsakes ✳ color photocopies of family photos

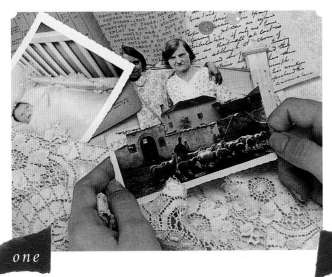

one

Gather Your Collage Elements

Begin by sorting through the various elements that you have gathered that relate to the person you would like to celebrate in this collage. Look at the list of suggested items on page 12 for inspiration. Make a small pile of the items that speak to you the most and set the others aside.

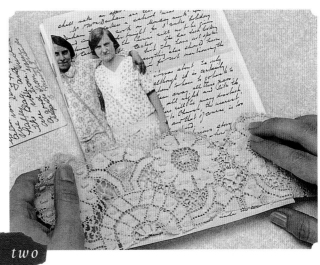

two

Experiment With Different Layouts

Pick out a photo of the person (or people) you would like to feature. Look for a large image; you want the viewer to know who this collage is about at first glance. Choose a few other elements and begin experimenting with different arrangements on your canvas.

I start my collage with this image of the cousins. It doesn't bother me that one of the girls is cropped a bit; the image is nice and large, and I like how they have their arms around each other. I also add a copy of an old letter and a strip of vintage lace to the bottom for texture.

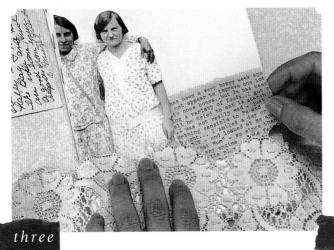

three

Make Needed Changes

Look at your initial arrangement. Do the elements work well together? Don't feel that you have to crowd your collage with everything you found. Sometimes a few well-chosen pieces can capture a personality best. Remove any elements that don't seem to work.

In this piece, the text of the handwritten letter feels a little too busy. It competes with the photo of the cousins. I pull that out and add a much smaller scrap of a typed letter instead.

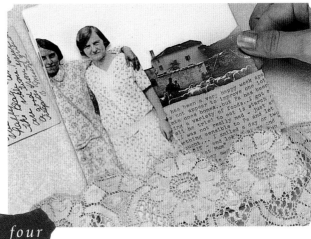

four

Add Personal Symbols

Think about the person in your collage. What makes that person special? Look for objects or images that express something unique about him or her. It could be a descriptive word or phrase, a photo of that person's favorite place, or an object that symbolizes a particular interest or accomplishment.

For this story, the ranch where these cousins met is full of memories, so I add a photo of it behind them. This composition is starting to come together now. Notice how the typed letter creates a horizon line and the house falls perfectly behind that letter. The collage now has more depth with the building in the distance.

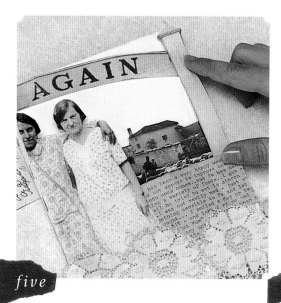

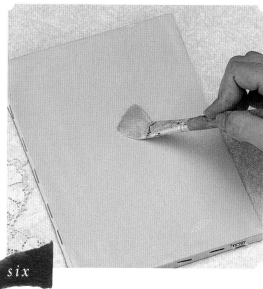

five

Complete the Composition

Does your collage tell a good story? When you are happy with the main message, look at adding some finishing touches. Use buttons or fabric to add a bit of color or texture where it seems to be missing.

I wanted something to fill in the space above these girls to make the collage more intimate. I discover a photocopy of what looks like a ranch sign to frame them. I love this element; the word **again** makes me think that these cousins would love to go back to that time and place.

six

Paint the Background

Up until now, we have been arranging these items on a blank, white canvas. If your canvas is not completely covered by your collage, carefully set aside all the elements and paint or glaze the background with a color that complements your composition. I paint this canvas a very light blue to represent a hazy summer sky.

⭐ **frame it** For an elegant finishing touch, frame your collage and display it in your home as a daily reminder of someone special to you. You can buy a picture frame or turn to page 16 for tips on how to make your own quick collage frame.

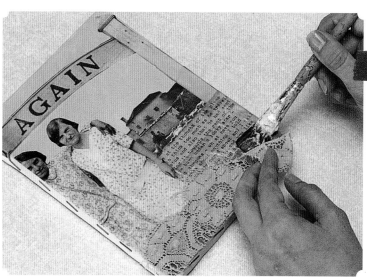

seven

Glue Down the Pieces

Now everything is ready to be glued down. Using gel medium, carefully glue down all the elements one by one. If you have a lot of items made of paper in your collage, brush a layer of gel medium on top to protect them.

⭐ **where to find great words** You can gather text from many different sources: books and novels, magazines and catalogs, dictionary pages, old letters and encyclopedias. When you look through them, try to find words or phrases that you like. Copy or cut them out and put them in a box. Then when you are working on a piece you will have an assortment of words ready to choose from.

My favorite way to find good words is to buy inexpensive old romance novels from the thrift store. The text from romance novels can be very funny when taken out of context. The words are so dramatic!

{Using Words} TO TELL A *story*

They say that a picture is worth a thousand words, but sometimes the opposite is true. Words can make a big difference in your collages. I really enjoy adding text to my collage pieces because it helps tell a story to the viewer. Add a word or two to any collage and it's amazing how the words can change your impression of the entire piece.

I suggest you try adding words to some of your collages and see what happens. To demonstrate what I mean, I have created a little assemblage and will show how adding one word can alter the direction of the story.

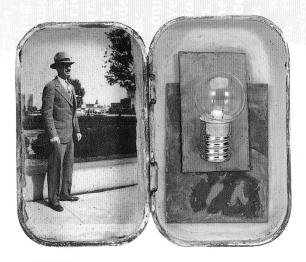

Before

Here is a miniature assemblage I created inside a mint tin. We see a man standing in a park and a miniature light bulb opposite him. What comes to mind as you look at this assemblage? Does the light bulb make you think that the man might be an engineer? A strange man with an idea? Could he be a businessman or an entrepreneur? If you had to choose a word to go with this assemblage, what would it be?

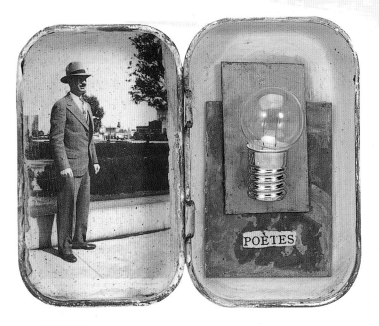

After

Look at this assemblage now. Does the word **poetes** change your impression of the piece? Does it add a new and unexpected dimension to the personality of this man? You might imagine that he is a poet and this little box is all about the creative process of being a poet.

Now imagine what this piece would look like if the word **electrician** were used instead. All of a sudden, you have a very different impression of this man, don't you? Now he seems like a man on his way to his next job, not quite as romantic as a poet!

You can work on your collage with an idea in mind from the start about what words might best complete your story. For example, if you are making a heritage collage in honor of your aunt Nan, who was a piano teacher, you might look for the words **teacher** or **musician** to add to your collage.

Unless it is a heritage collage, I like to leave these finishing touches up to chance. Simply choose a few random words and try them out on your collage and see which one speaks to you. You might be surprised by what comes out!

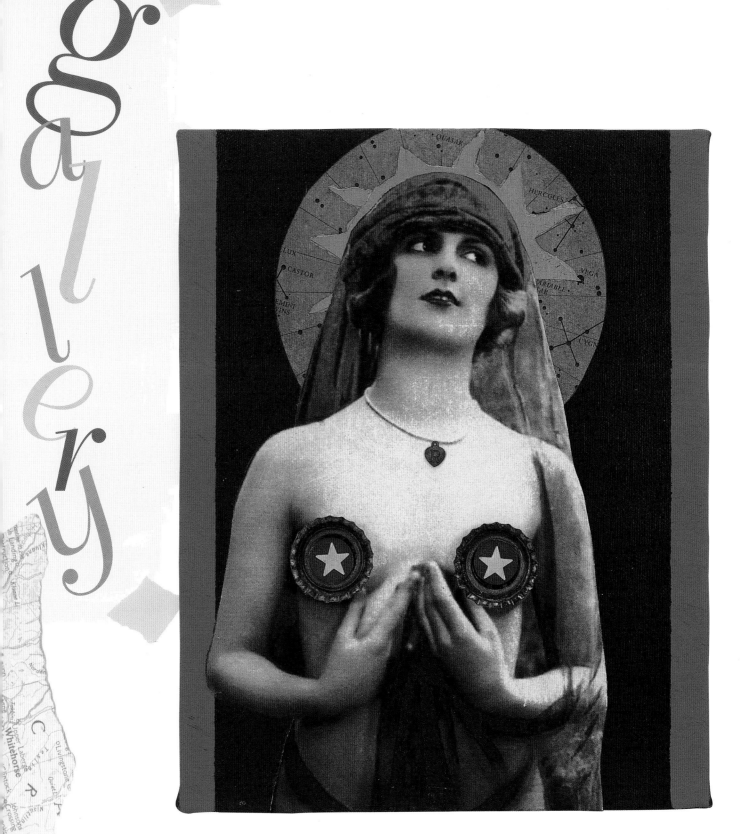

Princess Vega 10" × 8" (25.5cm × 20.5cm)

As a finishing touch to this whimsical collage, I added
bottle caps that were rusted in bleach and vinegar.

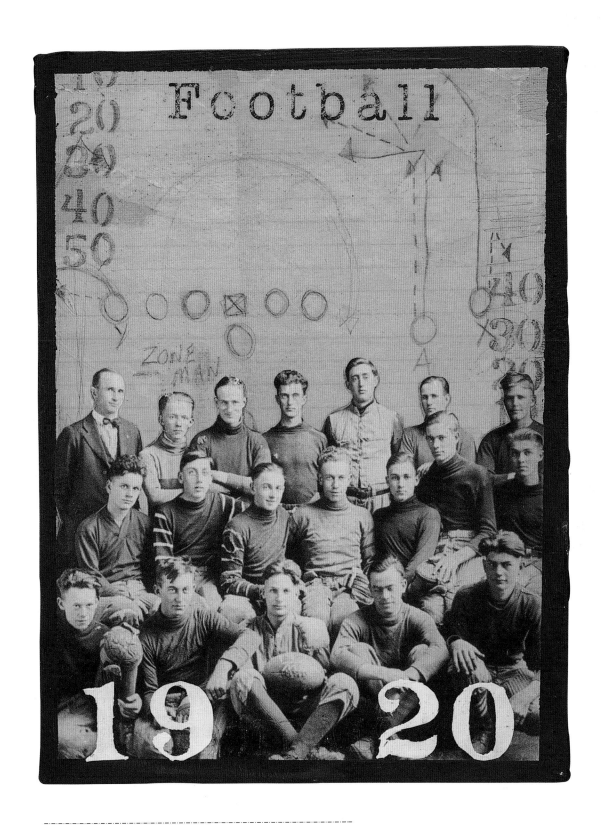

Football 12" x 9" (30.5cm x 23cm)

The word **football** was added to this nostalgic collage using the caulking transfer method. When the transfer was complete, I gently sanded the word to create an aged effect. The peeling paper technique was also used as a background effect.

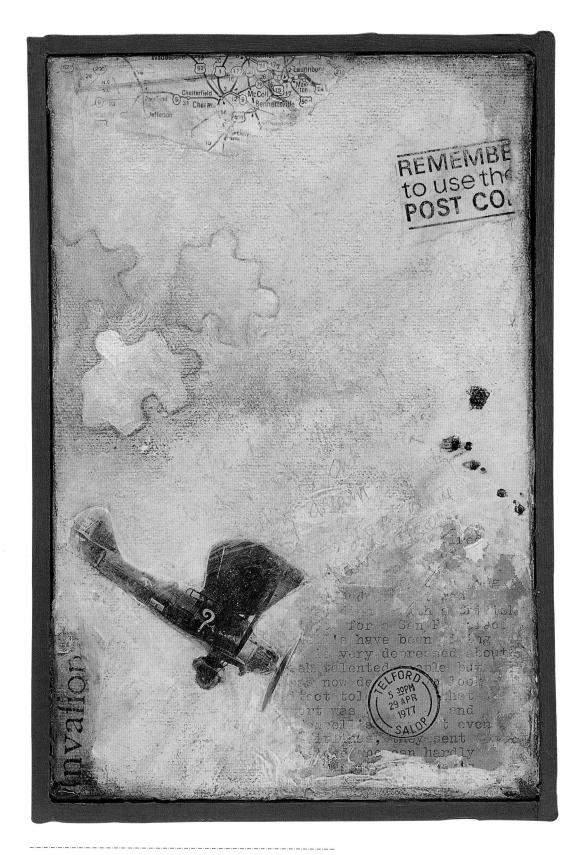

The Invitation 9½" × 6½" (24cm × 16.5cm)

I used scraps of a map and an old airmail letter layered over
with textured paint to create the background of this mysterious
collage. It created a dreamy effect that reminded me of clouds.

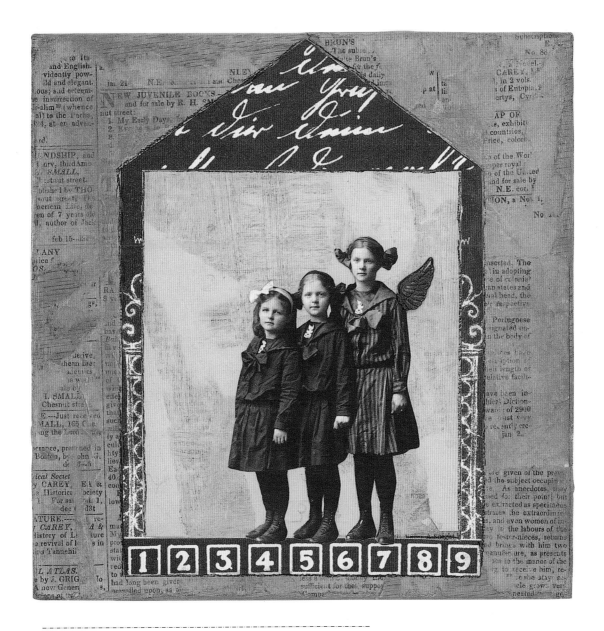

Three Girls and a Wing 7¼" × 7¼" × 1¾" (18.5cm × 18.5cm × 4.5cm)

This collage was created on the lid of a cigar box. The peeling paper created a nice neutral background to collage on top of. I tinted the paper with an ochre wash. The addition of the little brass wing charm turned out to be the perfect finishing touch.

Camel Travels 12" x 9" (30.5cm x 23cm)

In this piece I transferred the camel diagram on top of an old map image. One thing to think about when creating a transferred image is how busy your background is. If it is too busy or too dark, a transfer might not show up. In this piece, the background is close to being too busy, but it still works because of the muted colors of the map.

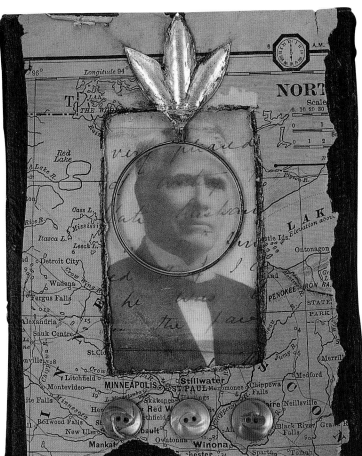

Through the Looking Glass

5" × 4" (12.5cm × 10cm)

I used contact paper and a photocopy of an old picture to create the translucent image transfer in this collage. I cut a square out of the canvas to allow light to come through the image.

The Sun

7" × 5" (18cm × 12.5cm)

The celestial background in this collage was created using the caulking transfer technique. It adds a subtle arched effect to the top of the canvas and draws your eye back to the focal point of the little boy. Notice that the text in this piece is backwards. It doesn't bother me. I was more interested in using the celestial image as a pattern.

Venus in a Box 6½" × 2" × 1½" (16.5cm × 5cm × 4cm)
The back of this little blue box is covered with beeswax. After I layered wax into the box, I transferred the Venus figure to the wax with nail polish remover. I also colored the background of the box using crayon drippings.

Setting Sun

7½" × 5½" (19cm × 14cm)
This collage was created entirely using beeswax. All the elements were glued down with wax. I added the red halo around the male figure using crayon drippings and then used a hot iron to spread the drippings into a halo shape.

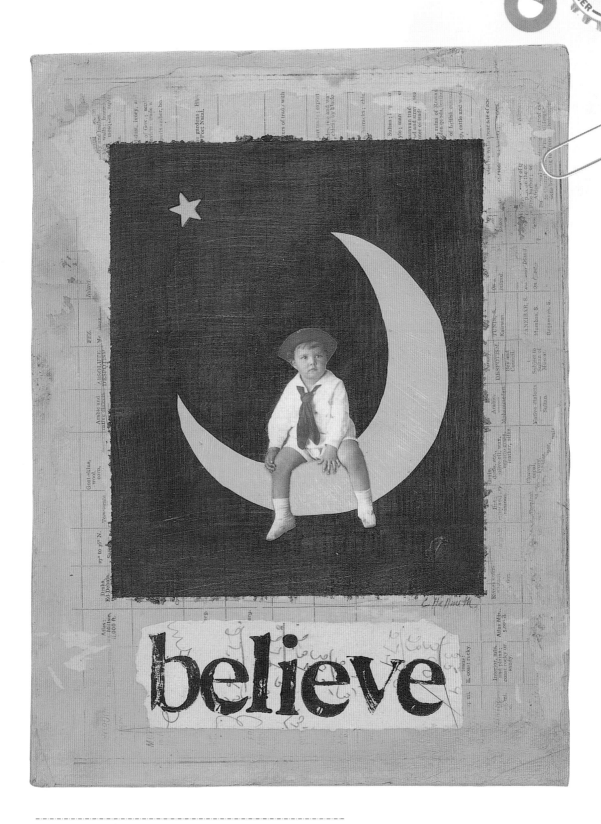

Believe 12" × 9" (30.5cm × 23cm)

I wanted to create an aged background for this collage but not
draw too much attention to it, so I used the peeling paper tech-
nique, but I didn't do a wash of paint over it. This helps the peeling
paper stand out less but still gives a nice effect.

collage and assemblage artists' *web sites*

There is nothing more inspiring than seeing the work of other artists. Personal Web sites have become a popular way for collage artists to post their work for others to see. Here is a list of some of my favorites.

PAMELA ALLEN

http://pamelart.homestead.com/titlepage.html
- Very intriguing assemblage artworks. Check out her use of color.

NINA BAGLEY DESIGN

www.itsmysite.com/ninabagleydesign
- Incredible jewelry and collage artworks. Her jewelry is to die for!

CHRISTOPHER BALES

www.christopherbales.com
- Wonderful assemblage artist!

MICHELLE CARDOZA

www.itsmylove.com/moonshinelane
- Lovely and thought provoking collages.

BETH COTE

www.alteredbook.com
- Incredible altered-book artist.

AISLING D'ART

www.aisling.net
- Wonderful mixed-media artist.

LAURIE DOCTOR

http://lauriedoctor.com
- Moving and poetic mixed-media artwork.

SARAH FISHBURN

www.frii.com/~gerety/sarahfishburn
- Altered books, collaborative work, mixed media.

MELISSA MCCOBB HUBBELL

www.melissamccobbhubbell.com
- Beautiful collages, both digital and handmade.

KEITH LO BUE

www.lobue-art.com
- The most incredible found-object jewelry that I have ever seen.

SARAH LUGG

www.sarahlugg.com
- Collage artist and mixed-media work. She has become famous for her tag art featured in *Victoria* magazine. I love her whimsical designs.

KAREN MICHEL

www.karenmichel.com
- Altered books, mixed-media paintings, art journals. She does it all!

CATHERINE MOORE

www.itsmysite.com/catherinemoore
- Beautiful artworks from an Atlanta-area artist. Take a peek at her House Shrines!

TEESHA MOORE

www.teeshamoore.com
- Talented mixed-media artist. Hosts Artfest, an artist retreat held in Port Townsend, Washington, every year.

LINDA AND OPIE O'BRIEN

www.burntofferings.com
- Wonderful collage and assemblage artworks by this husband-and-wife team.

OISEAUX SISTERS

www.oiseauxsisters.com
- These two sisters will blow you away with their mixed-media creations.

LYNNE PERRELLA

www.lkperrella.com
- Fascinating mixed-media artist, who also owns the rubber-stamp company Acey Deucy.

JUDI RIESCH

www.itsmysite.com/judiriesch
- Wonderfully talented collage and mixed-media artist.

LESLEY RILEY

www.lalasland.com
- Check out her Fragments. These tiny collages she does with fabric are amazing!

CATHY ROSE

www.cathyrose.com
- Assemblage artist extraordinaire!

JAMES MICHAEL STARR

www.jamesmichaelstarr.com
- Elegant and poetic collages.

PAT STREET

www.patstreet.com
- Beautiful artwork. She makes both traditional and digital collage; both are equally amazing.

KATHERINE STREETER

www.streeterart.com
- Illustration artworks and fine art collage. I love the things she does with baby-doll heads.

SUMMER PLACE

http://homepage.mac.com/summerplace
- Fabulous quirky retro collage artwork.

JONATHAN TALBOT'S STUDIO

www.talbot1.com
- Painter, printmaker and collage artist. Fascinating artwork!

publications *of interest*

MICHELLE WARD
www.itsmysite.com/michelleward
• Multitalented collage artist, rubber-stamp designer and everything in between.

LYNN WHIPPLE
www.whippleart.com
• Lynn's work will move you! Check out her Ninnies—collage with a wonderful touch of humor.

BRIONIE VARDON WILLIAMS
www.mysticartisian.com
• Collage and mixed-media artist.

JANE WYNN
www.absintheart.com/jane
• Mixed-media artist and creator of incredible assemblage jewelry.

KARENANN YOUNG
www.itsmyidea.com/karenannyoung
• Collage, assemblage and mixed-media artist.

The following list of magazines and small art zines are full of further inspiration and techniques for the collage artist.

ART CALENDAR MAGAZINE
P.O. Box 2675
Salisbury, MD 21802
(410) 749-9625
Toll-free: (866) 4ARTCAL
www.artcalendar.com

ARTITUDE ZINE
117-2017 A Cadboro Bay Road
Victoria, BC V8R 5G4
Canada
(250) 370-9985
www.artitudezine.com

DOG EARED MAGAZINE
P.O. Box 17545
Seattle, WA 98107
www.dogearedmagazine.com

EXPRESSION MAGAZINE
591 Camino de la Reina, Suite 200,
San Diego, CA 92108
(619) 819-4520
www.expressionartmagazine.com

THE GLEANER (Internet only)
http://groups.yahoo.com/group/thegleanerzine

IN(NER) QUESTION
Eliza Badurina
112 South 9th Street
Norfolk, NE 68701
www.moderngypsy.com/iq

MYSTERIUM
Megan Noël
3817 Evanston Avenue N #303
Seattle WA 98103-8555
www.megannoel.com/mysterium.html

NEW AMERICAN PAINTINGS
The Open Studios Press
450 Harrison Avenue #304
Boston, MA 02118
Toll-free: (888) 235-2783
www.newamericanpaintings.com

PLAY
Alternative Arts Productions
P.O. Box 3329
Renton, WA 98056
www.teeshamoore.com

READYMADE MAGAZINE
2706 Eighth Street
Berkeley, CA 94710
(510) 549-6400
Toll-free: (866) 851-3369
www.readymademag.com

SOMERSET STUDIO MAGAZINE
22992 Mill Creek, Suite B
Laguna Hills, CA 92653
(949) 380-7318
Toll-free: (877) STAMPER
www.somersetstudio.com

STUDIONOTES
P.O. Box 502
Benicia, CA 94510-0502
(707) 746-5516
www.studionotes.org

suppliers of *collage materials*

Most of the collage supplies used in this book are readily available at your local art or craft store. If you have difficulty finding something, try contacting the suppliers listed below.

US Resources

ARTCHIX STUDIO
1957 Hampshire Road
Victoria, BC V8R 5T9
Canada
Tel: (250) 370-9985
Fax: (250) 370-0985
www.artchixstudio.com
• collage sheets of antique photos and more

COLLAGE JOY
Leanne Bishop in the United States:
250 H Street #671
Blaine, WA 98230
in Canada:
916 West Broadway #475
Vancouver, BC V5Z 1K7
Canada
www.collagejoy.com
• vintage collage and assemblage supplies

DICK BLICK ART MATERIALS
P.O. Box 1267
Galesburg, IL 61402-1267
Toll-free: (800) 828-4548
www.dickblick.com
• heat-transfer tool, brushes, art canvas

GOLDEN ARTIST COLORS
188 Bell Road
New Berlin, NY 13411-9527
Toll-free: (800) 959-6543
www.goldenpaints.com
• Golden paints and gel medium; available at most art and craft stores

GREEN GIRL STUDIOS
P.O. Box 546
Ojai, CA 93024
Tel: (805) 640-6722
Fax: (805) 640-6712
www.greengirlstudios.com
• tiny little beads and incredible charms for use in your assemblages

LEE VALLEY TOOLS
www.leevalleytools.com
• order watchmaker's tins from the garden storage section of their Web site or visit one of their eleven Canadian stores

MANTO FEV
1118 South 54th Street
Omaha, NE 68106
Tel: (402) 558-6813
www.mantofev.com
• packets of collage supplies, charms

UK Resources

FRED ALDOUS
37 Lever Street
Manchester M1 1LW
Tel: 08707 517 303
www. fredaldous.co.uk
• shop and mail order craft materials

HOMECRAFTS DIRECT
P.O. Box 38
Leicester LE1 9BU
Tel: 0845 458 4531
www.homecrafts.co.uk
• mail order for craft materials

PAPERCHASE
213 Tottenham Court Road
London W1P 9AF
Tel: 020 7467 6200
• shop for handmade papers

HOBBY CRAFTS
River Court
Southern Sector
Bournemouth International Airport
Christchurch
Dorset BH23 6SE
Tel: 0800 272387
Retail shops nationwide.
Telephone for a local store.
• craft supplies

Internet-Only Resources

DOVER PUBLICATIONS PICTORIAL ARCHIVE
www.doverpublications.com
• search their Pictorial Archive series of all copyright-free images

EBAY
www.ebay.com
• search their listings for vintage papers and photos

ECLECTIC EPHEMERA
www.itsmysite.com/michellezerull
• packets of antique papers and elements

FOUND ELEMENTS
www.foundelements.com
• collage materials

index

get creative
with these fine North Light books!

These books and other fine North Light titles are available from your local art or craft retailer, bookstore, on-line supplier or by calling toll free, 1-800-448-0915.

Making Greeting Cards With Creative Materials

You can learn to make beautiful greeting cards and gift tags all with handy, eye-catching materials used in clever ways. Blending fun and user-friendliness with variety and creativity, this book encourages crafters to go beyond basic greeting cards to design unique projects. Techniques are easy and illustrated—from basic folds and simple cuts to extravagant embellishments with silk threads, glass beads, rubber stamps, charms, watercolor washes and other creative but readily available materials. ISBN 1-58180-126-2, paperback, 128 pages, #31818-K

Creative Correspondence

Send your friends and family some mailbox cheer! Discover 16 fun, easy-to-follow correspondence projects, ranging from clever self-mailers and postcards to letters and envelopes with photo inserts, stapled booklets, special pockets and see-through address windows. You'll learn how to embellish your letters with colored pencils, rubber stamps, custom address labels and colorful flaps and stickers. Includes recipes for decorating plain paper with stamping, combing and bubble marbling. ISBN 1-58180-317-6, paperback, 96 pages, #32277-K

Making Gifts With Rubber Stamps

Use your favorite rubber stamps to create 25 gorgeous gifts and miniature works of art! Inside you'll find dozens of simple methods for creating sophisticated embellishments on everything from lamp shades and push pins to clever mini shadow boxes and handmade books. ISBN 1-58180-081-9, paperback, 128 pages, #31667-K

How to Be Creative if You Never Thought You Could

Let Tera Leigh act as your personal craft guide and motivator. She'll help you discover just how creative you really are. You'll explore eight exciting crafts through 16 fun, fabulous projects, including rubber stamping, bookmaking, papermaking, collage, decorative painting and more. Tera prefaces each new activity with insightful essays and encouraging advice. ISBN 1-58180-293-5, paperback, 128 pages, #32170-K